DUOTONES

TRITONES

AND

QUADTONES

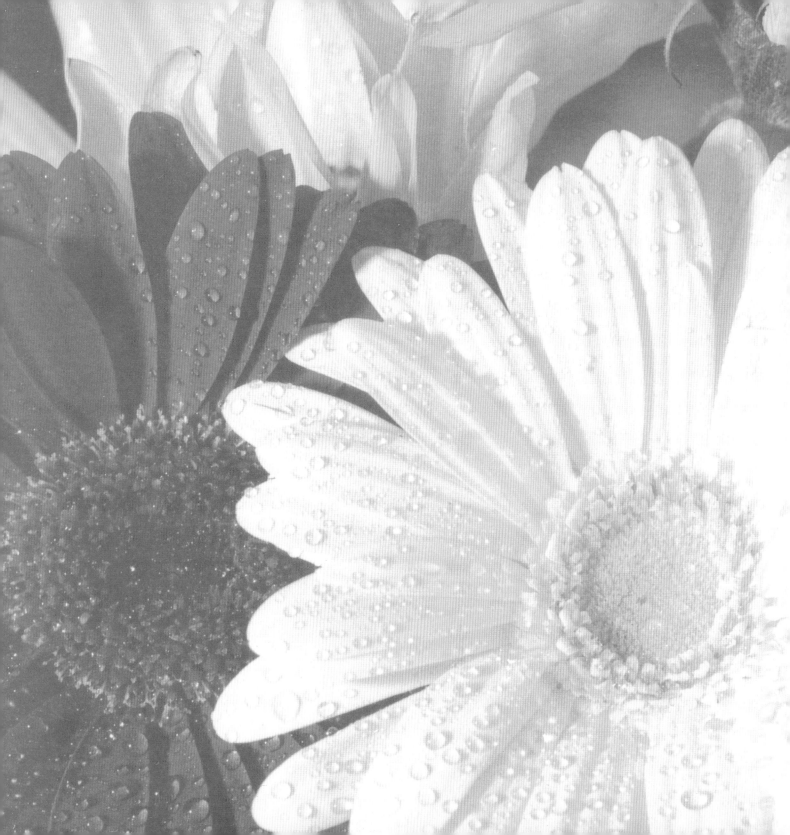

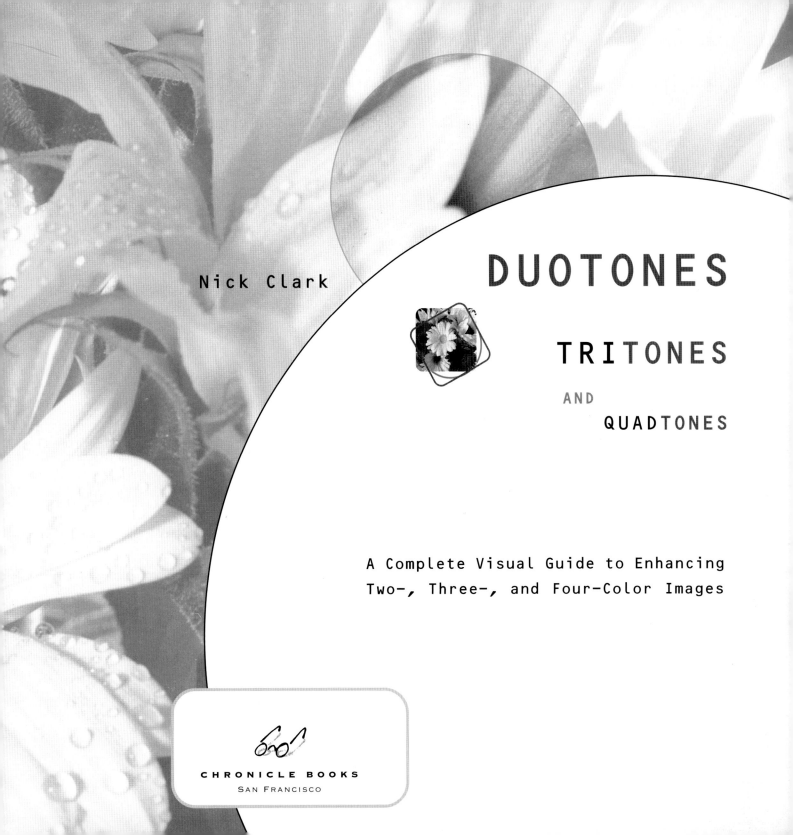

Nick Clark

DUOTONES

TRITONES

AND

QUADTONES

A Complete Visual Guide to Enhancing
Two-, Three-, and Four-Color Images

CHRONICLE BOOKS
SAN FRANCISCO

First published in North America in 1997 by
Chronicle Books

Copyright© 1997
Quarto Inc.

Originated in Hong Kong by
Regent Publishing
Services Ltd., Hong Kong

Produced and designed by
Quarto Publishing plc,
The Old Brewery
6 Blundell Street
London, N7 9BH

Picture Researcher: Miriam Hyman
Senior Editor: Kate Kirby
Text Editor: Cathy Meeus
Picture Research Manager: Giulia Hetherington
Editorial Director: Mark Dartford
Art Director: Moira Clinch
Cover Design: E. Lokelani Lum-King
 Skolos/Wedell, Inc.

ISBN: 0-8118-1426-2

Library of Congress
Cataloging-in-Publication
Data available.

Printed in China

Distributed in Canada by
Raincoast Books
8680 Cambic Street
Vancouver, B.C. V6P 6M9

10 9 8 7 6 5 4 3 2 1

Chronicle Books
85 Second Street
San Francisco, CA 94105

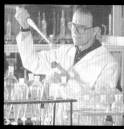

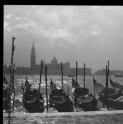

Contents

Monotones, duotones, tritones and quadtones

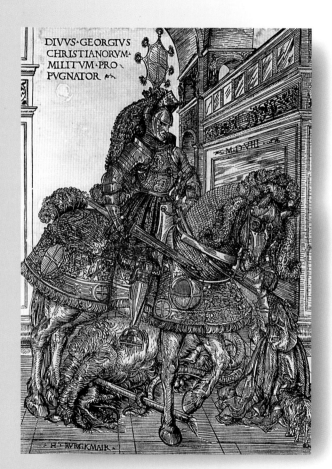

St. George on Horseback HANS BURGKMAIR
CHIAROSCURO WOODCUT 1508
One of the first true chiaroscuro woodcuts

"A duotone is a two-color halftone image made from a single piece of continuous-tone, black-and-white copy with both printed images recording the approximate tonal relations of the original. The image printed with the darkest color emphasizes the shadow end of the illustration, while the image printed with the lightest color emphasizes the highlight end."

ERWIN JAFFE, LITHOGRAPHIC
TECHNICAL FOUNDATION, INC.

The earliest "duotones" were probably the chiaroscuro woodcuts of the early 16th century. These woodcuts were printed using two or more color blocks, which provided the overall background tone for the composition while the paper itself provided the highlights. Unlike standard woodcuts, the colors of chiaroscuro woodcuts were generally closely related, because the emphasis was on the depiction and differentiation of tonal values rather than on color.

In essence, the contemporary duotones set out to achieve a similar effect. The variation of tonal values between each printing plate creates the distinctive style of a duotone. In addition, the use of special colors, instead of the process colors – cyan, magenta, yellow, and black – used in four-color printing provides effects that cannot always be achieved within the four-color printing process. That is not to say that duotones cannot be specified in the four-color process, indeed they are often used in books and magazines when a black-and-white halftone needs

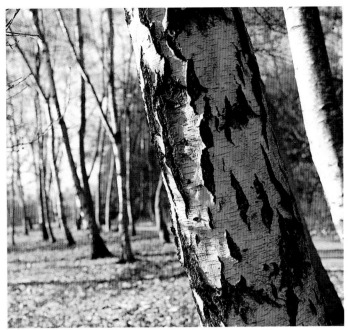

A monotone print with good strong blacks and shadow areas, bright highlights, and varied tonal ranges.

A standard duotone conversion from a monotone print. The second color is magenta.

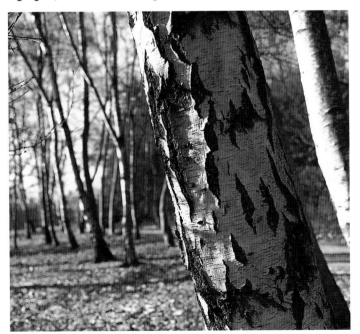

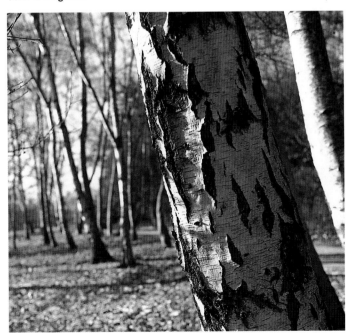

A standard tritone conversion from a monotone print. The second color is magenta and the third color is cyan.

A standard quadtone conversion from a monotone print. The second color is magenta, the third color is cyan, and the fourth color is yellow.

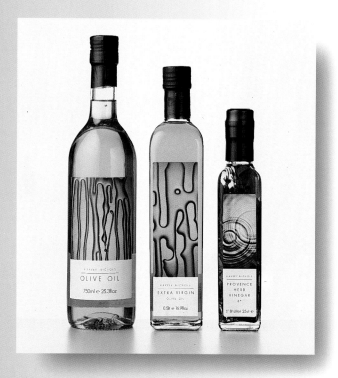

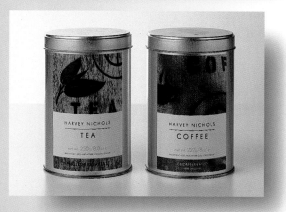

Packaging is an area of design where duotones can be very effective, although they are not often used. The abstract quality of the images used on these food labels is emphasized by the careful selection of special colors. The duotones contribute to the simplicity of the overall look, whereas the use of full color would have over-complicated the designs. This range of products uses duotones successfully on media ranging from tins and glass to paper and plastics.

the added "lift" of a second color (cyan, magenta, or yellow) but the budget does not allow for a fifth, special color, printing plate. In fact, the use of tritones and quadtones with the four-color process and various combinations of cyan, magenta, yellow, and black offers a vast number of ways of tonally coloring monotone images and of achieving pleasing color effects from black-and-white originals.

Duotones

A duotone is a monochrome image, usually created from a photograph, from which two films (or printing plates) have been made that, when combined, produce a single image. Each film can be printed in a different color with the darker, or "primary" color often being black. The primary film is angled at 45 degrees and the secondary film usually at 75 degrees to avoid moiré patterns. When the negatives are shot the tonal scale between the two films is changed slightly to create the duotone effect. The primary negative is produced as a normal halftone, except that the shadow dot is slightly larger than normal. The secondary negative is produced with little or no dot in the shadow areas and increased dot in the highlight areas. When proofed this allows the second color to appear stronger in the shadow detail areas. There are also areas of true white, or non-printed paper, where the highlights of the halftone show clearly. This is one of the key characteristics of duotones.

It is also worth noting that duotones are not simply used as a method of introducing some color to a monochrome image. Importantly, they can also be used to increase the tonal range of a grayscale image. A normal grayscale image can display up to 256 levels of gray, but the printing press generally allows only about 50 levels of gray per ink. The introduction of a second color therefore effectively doubles this range. The image looks richer and stronger on the page and attracts more attention. In the examples on pp.112-119, where black and gray inks have been specified, the black ink captures the shadow details

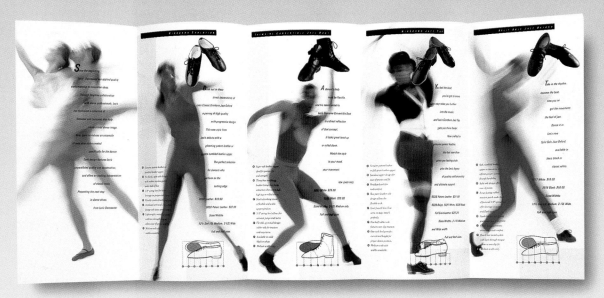

These exuberant images were created through the use of tritones and quadtones. The dancers were photographed in black-and-white film, which gives both the photographer and the designer a more consistent style of image with which to work. These were then converted into a variety of colorways. To use full color photography to create this look would be difficult, if not impossible.

Calendars offer great opportunities to use duotones in large formats. Here, superb reportage black-and-white photographs were converted into duotones to produce classic, strong images. All the highlights, midtones and shadow areas are beautifully controlled by high quality origination and printing.

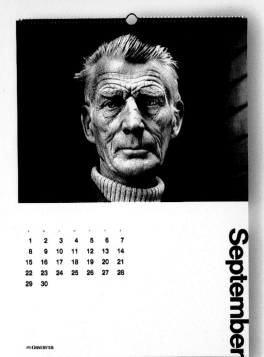

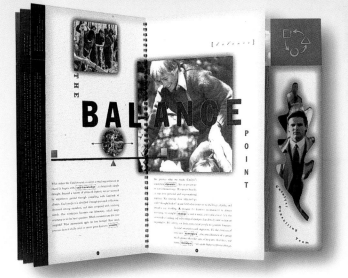

This brochure uses duotones in a variety of colors. The photographs on each double-page spread use the same color combinations, chosen to interact pleasingly with the inside back cover image on the right. It is interesting to note that while the pictures themselves are not always strong compositions, the clever use of duotones in special colors enhances the impact of each photograph.

In this artists' figure reference book, color transparencies were converted to duotones to allow for the book's two-color specification. By using a brown and a blue ink, and by avoiding the normal choice of black, it was possible to simulate a full color effect. The blue looked natural for clothing and fabrics such as denim, while the brown worked for the skin tones. When combined, the colors produced the strong darks for areas such as shoes or hair. This ingenious use of duotones shows that a restricted budget does not have to mean a restricted design.

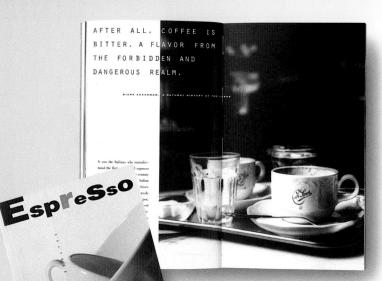

AFTER ALL, COFFEE IS BITTER, A FLAVOR FROM THE FORBIDDEN AND DANGEROUS REALM.

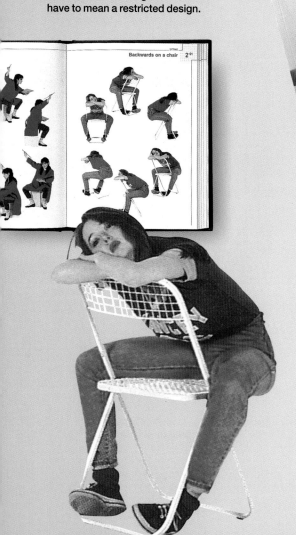

Duotones and sepia-tones (a common form of quadtone) are used extensively in books. There are a number of possible reasons for this. The budget may dictate that a book is to print in only two colors, in which case duotones are the only way of introducing a four-color effect into the images. Or it may be that the original images are monochrome and need to be enlivened by printing them as tritones and quadtones. In some cases the subjects, although appearing in a four-color publication, look best as duotones.

The *Espresso* book shown here uses subtle quadtones to capture the mood of the subject. Although the book has a four-color print specification, it was appropriate to use quadtones to enrich the monotone images used for chapter openers thereby reinforcing the continuity of the book.

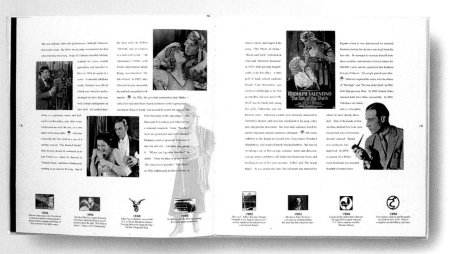

In a book celebrating Hollywood most of the archive prints were available only as monotone subjects. The design style suits the subject matter of the book and is an excellent use of combinations of duotones, tritones, and quadtones to achieve a variety of color effects.

while the gray ink is used in the midtone and highlight areas. This is a particularly useful method for reproducing photographers' black-and-white prints in, for example, an exhibition catalog. A more unusual, but equally effective method is to use a silver ink instead of gray.

Tritones

A tritone uses three films of the same monochrome image. Each film prints in one color with the primary color again usually being black. The primary film is angled at 45 degrees, with the second and third films at 30 degrees to the black plate – normally at 75 and 15 degrees. As with a duotone, the screen angling between films is necessary to prevent moiré patterns from occurring. A tritone image can produce a greater range of tones than a duotone, from strong highlights (clear white paper) to very dense, rich shadows.

Quadtones

A quadtone (sometimes called a quadratone) is produced from a monochrome image printed from four halftone films. Quadtones cover the greatest tonal range and potentially the widest variety of color possibilities. The most common use of quadtones is to create sepia-tones. These are, for all intents and purposes, quadtones when printed using the four process colors (cyan, magenta, yellow, and black) in, say, a four-color publication. Usually the easiest way to specify a sepia-tone is to show an example of the color you wish to achieve.

Why not color?

There are many reasons for not using full color even if it is available. Duotones can impose uniformity on varied images – in color there is more to distract the eye. A quadtone sepia-toned photograph can be used to create a nostalgic effect. Designers often use quadtones to give a work stronger continuity – there are many examples of corporate brochures, some shown on these pages, where the limited use of color helps to provide a unified look.

It is worth remembering that instead of using the four-color process for quadtones, you could choose a palette of four special colors. This may seem rather limiting at first but it is surprising how versatile they can be and, most importantly, these special colors can give a unique quality to your work.

Lastly don't forget an obvious but often overlooked possibility – you can always convert a color image to grayscale. A converted color subject can look unexpectedly effective as a duotone, tritone, or quadtone.

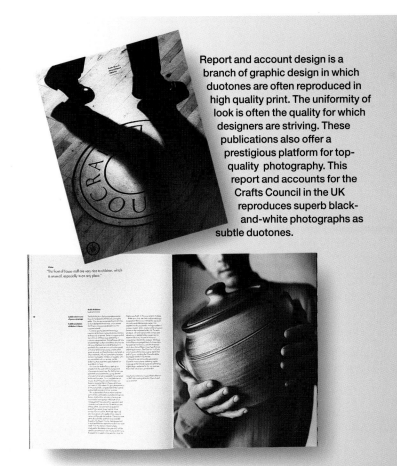

Report and account design is a branch of graphic design in which duotones are often reproduced in high quality print. The uniformity of look is often the quality for which designers are striving. These publications also offer a prestigious platform for top-quality photography. This report and accounts for the Crafts Council in the UK reproduces superb black-and-white photographs as subtle duotones.

How to specify what you want

Today's designer using up-to-date desktop-publishing equipment no longer has the problems that used to exist when specifying duotones, tritones, and quadtones. Before such systems were available it was difficult to predict exactly what the color would look like when a subject returned from the origination house. Different technicians had different views on what should be a standard or default setting for a duotone. Because of the thousands of color permutations available, the final color was often even more difficult to predict when specifying tritones and quadtones. But it is the versatility of these seemingly endless colorways that makes the use of tritones and quadtones especially exciting, if at first daunting, for the contemporary designer.

Imaging software

There are many imaging software packages available but the most widely used by designers and origination houses now is Adobe Photoshop. The explanation of the complete specification process for duotones, tritones, and quadtones is best left to the instruction manual for the particular application you are using. However, this chapter gives a brief overview of the main process needed to specify a required effect correctly to an origination house.

The image

In the first place, it is important to decide the resolution to which the image should be scanned. This is not important if you are preparing a low resolution file, say 75dpi, for a general positional guide to the origination house. If, however, you are preparing final reproduction quality

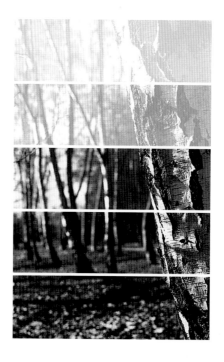

Scanning software now makes it possible to plot tonal curves (known as null curves) to improve the quality of tones in specific areas. The monotone image, left, shows a standard inked (i.e. default) midtone range. Reduced and increased midtone percentages are shown above and below respectively. Tonal ranges are easily adjusted by the use of imaging software, opening up a vast range of possibilities for adjusting highlight, midtone, and shadow areas.

The default duotone shown left has been printed in process black and magenta inks. The details show the dot enlarged 500% for both films, clearly illustrating the two screen angles used – 45° for the primary, black film and 75° for the secondary, magenta film. It is also possible to see the difference in the individual dot shapes. The black film is a normal halftone negative, with the shadow dot slightly larger than usual. The magenta film is flatter and more open in the highlights, with the shadow areas almost solid or with very fine dot. This means that when printed the black has quite open shadows while the lighter color is heavier in the shadow areas, allowing the color to come through pleasingly.

Primary color negative shows shadow dot slightly larger.

Secondary color negative shows dot very dense in the shadow areas.

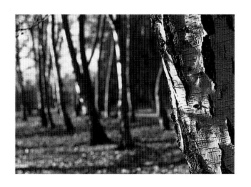

To create a default duotone, convert the subject to grayscale mode. Open the duotone menu and select two colors (black and cyan in this case). It's that simple!

The default setting is easily recognized as a straight diagonal line across the grid.

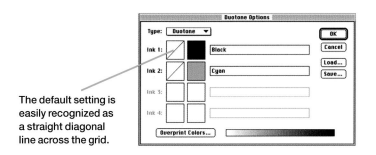

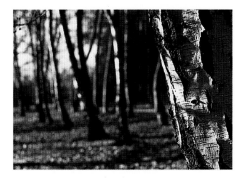

Adjusting your tritone is also a simple task. By clicking on the curve box a further box appears showing the null curve in detail (see p.14). This allows fine-tuning of the percentage of ink used to print an image.

The default setting has been altered as shown by the curved diagonal.

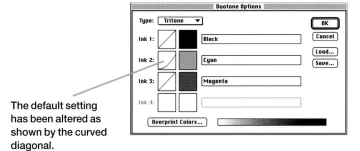

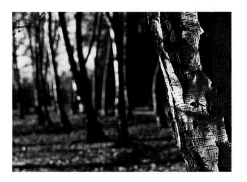

A default quadtone is achieved by clicking on quadtone and selecting your four colors. Like the duotone above, each null curve can be fine-tuned separately.

This quadtone has been specified in the four process colors. Black is Ink 1 because it is the darkest color. Yellow, the lightest color, is Ink 4.

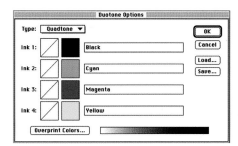

images yourself, you will have to decide, in conjunction with your printer, the best resolution to which to work.

When you have scanned in the image, it should be converted to a grayscale image. This allows you to go to the duotone option under the Mode menu. Once this has been done, the duotone options dialog box appears.

Within this menu it is an easy matter to specify the type of image – duotone, tritone, or quadtone – and the ink colors for the image. You can choose colors from Photoshop palettes, from the PANTONE color system, or from the four process colors.

If you stay only in this menu, your duotone, tritone or quadtone will be specified according to the default setting. This means that the duotone curve (also called a null curve) remains unaltered as a straight diagonal line across a grid.

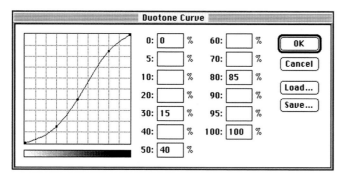

```
Duotone Curve

0:   [0]  %    60: [   ] %       [ OK ]
5:   [  ] %    70: [   ] %      [Cancel]
10:  [  ] %    80: [85] %       [Load...]
20:  [  ] %    90: [   ] %      [Save...]
30:  [15] %    95: [   ] %
40:  [  ] %   100: [100] %
50:  [40] %
```

The duotone curves

A further menu can be called up from the options dialog box. By clicking on the box to the left of the selected color you can call up the Duotone Curve dialog box. Once you have called up this box it is possible to manipulate a duotone to very exacting and varied specifications (see left). This is where the modern designer benefits – you can experiment and create a vast range of effects by adjusting highlights, shadows, and midtones – a privilege that used to be the sole preserve of the origination house.

Once you have achieved the required effect, the image file can be sent for origination without the need for you to worry about the final printed result – as long as your monitor is correctly calibrated and shows true color.

Duotones are one of the simplest forms of image manipulation available in applications such as Photoshop. If you exploit the variations permitted by adjustments to the duotone curves, you can produce unusual and dramatic images with guesswork reduced to the absolute minimum.

An adjusted duotone (null) curve dialog box. The boxes of the 0 to 100% scale remain blank in the default setting, shown as a straight diagonal across the grid. The straight diagonal indicates that for each grayscale value, a halftone dot of the same value is created for that ink. In one of the adjustments shown above, the midtone has been altered from 50% to 40%, which effectively lightens the midtone. You can set darker colors to print heavier in the shadows by moving the curve to the right, and light colors to print heavier in the highlights by moving the curve to the left.

Null curves adjusted to create a duotone in cyan and yellow.

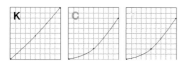

Null curves adjusted to create a tritone with green bias in black, cyan, and yellow.

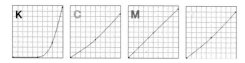

Null curves adjusted to create a quadtone with extra warm bias in all four process colors.

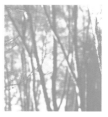

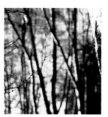

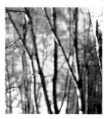

Proofing and printing

Always communicate with your origination house and printer if you are preparing your own duotones. Although they are simple to create on screen, you must make sure that screen angles are correct and that the colors being used are right for your print specification. Don't forget that what you see on screen is unlikely to look exactly like the final printed result – even the best screen calibration cannot be expected to recreate a precise match to a printed result.

However, what your system does allow is the freedom to experiment with duotones – bringing the control and creativity back from the origination house to you, the designer.

How to use this book

The following pages (pp. 16–127) show images printed as duotones according to a number of specifications to enable you to compare the effect produced by different settings and printing options. Each example shows the same settings in a standard position on the page. All examples are printed at 175 lpi using Adobe Photoshop® settings for image specification.

Default setting. The null curves remain at standard setting as straight diagonals across the grid. Both colors are inked at 100% with the black being the first color printed. The black film is at a 45° screen angle with the 2nd color at 75°.

This column shows a standard black-and-white halftone with the 2nd color as a flat tint inked in varying percentages. Although not a "real" duotone it is a method commonly used to create a two-color effect.

This column shows a default-setting duotone with the 2nd color scanned in reduced dot percentages from 75% to 25%. The black remains at 100% dot strength for each subject.

This column shows a default-setting duotone with the main color black scanned in reduced dot percentages from 75% to 25%. The 2nd color remains at 100% strength for each subject.

Default-setting duotone with both halftones produced in negative.

Default-setting duotone with each color gradated from 100% to 0% dot strength. The main color gradates in the opposite direction from the 2nd color.

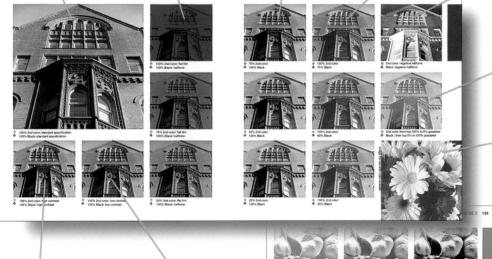

This image is for use with the acetate sheet supplied at the back of the book. Simply align the acetate colors to the register marks to see further possible color variations that do not use black in the duotone. The screen value is a coarse 75 dpi for ease of use.

High-contrast setting. The contrast is set when the subject is first scanned before conversion to a duotone. The setting above is +10, although any setting between +100 to -100 is possible.

Low-contrast setting of -7 on the contrast scale.

Pages 128 to 143 show a variety of tritone and quadtone images within specific color groupings, at default settings. They are also specified with reduced black dot percentages along each color row to show some of the subtleties that are possible.

Yellow

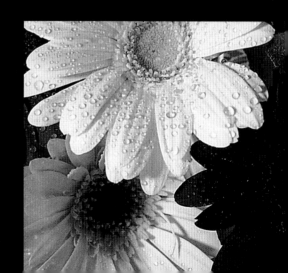

duotones

Cream　　　　　　　**Lemon yellow**　　　　　　　**Yellow**

Cream+**black** duotone

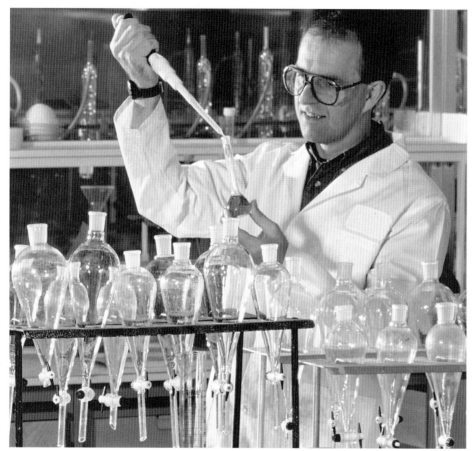

100% 2nd color: standard specification
❖ 100% Black: standard specification

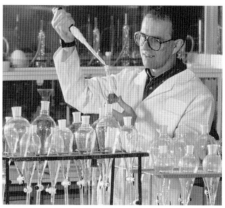

100% 2nd color: flat tint
❖ 100% Black: halftone

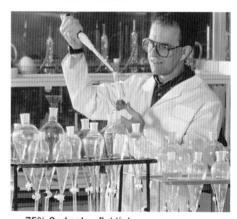

75% 2nd color: flat tint
❖ 100% Black: halftone

100% 2nd color: high contrast
❖ 100% Black: high contrast

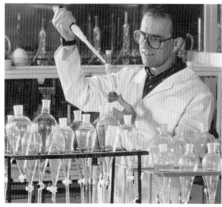

100% 2nd color: low contrast
❖ 100% Black: low contrast

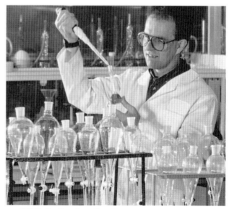

50% 2nd color: flat tint
❖ 100% Black: halftone

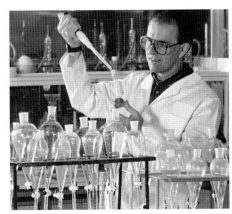

75% 2nd color
�֍ 100% Black

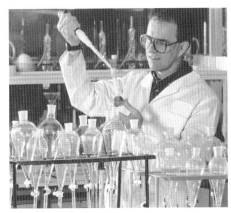

100% 2nd color
✤ 75% Black

2nd color: negative halftone
✤ Black: negative halftone

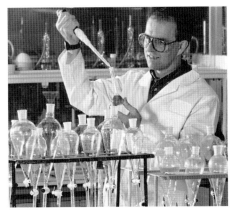

50% 2nd color
✤ 100% Black

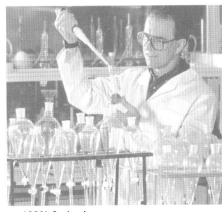

100% 2nd color
✤ 50% Black

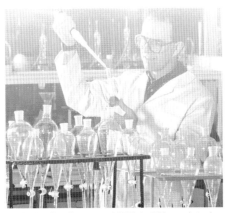

2nd color: from top 100% to 0% gradated
✤ Black: from top 0% to 100% gradated

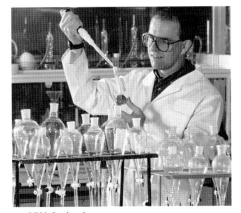

25% 2nd color
✤ 100% Black

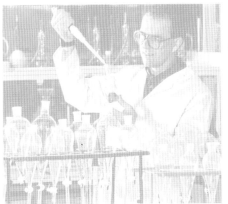

100% 2nd color
✤ 25% Black

Image for use with color acetate

Lemon yellow+black duotone

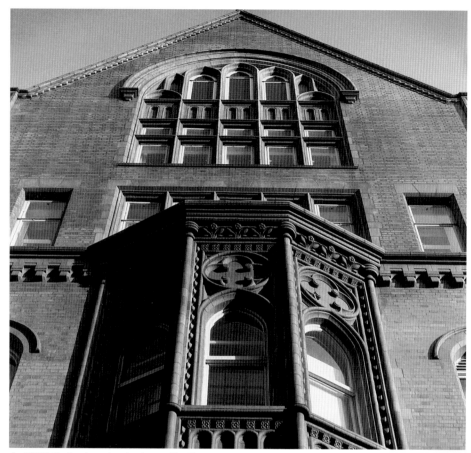

100% 2nd color: standard specification
❖ 100% Black: standard specification

100% 2nd color: flat tint
❖ 100% Black: halftone

75% 2nd color: flat tint
❖ 100% Black: halftone

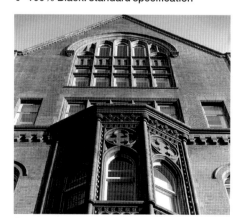

100% 2nd color: high contrast
❖ 100% Black: high contrast

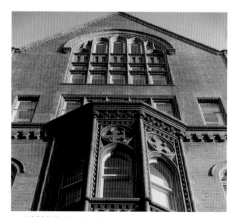

100% 2nd color: low contrast
❖ 100% Black: low contrast

50% 2nd color: flat tint
❖ 100% Black: halftone

75% 2nd color
❖ 100% Black

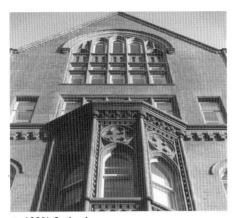

100% 2nd color
❖ 75% Black

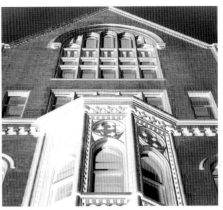

2nd color: negative halftone
❖ Black: negative halftone

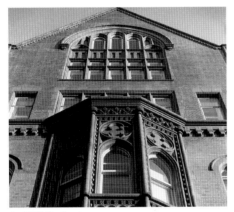

50% 2nd color
❖ 100% Black

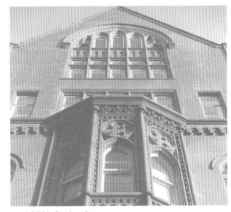

100% 2nd color
❖ 50% Black

2nd color: from top 100% to 0% gradated
❖ Black: from top 0% to 100% gradated

25% 2nd color
❖ 100% Black

100% 2nd color
❖ 25% Black

Image for use with color acetate

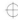

Yellow+**black** duotone

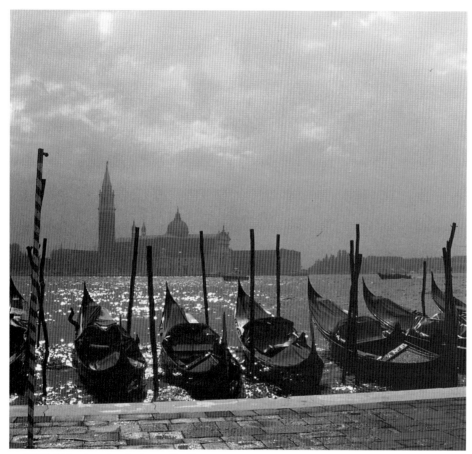

100% 2nd color: standard specification
✤ 100% Black: standard specification

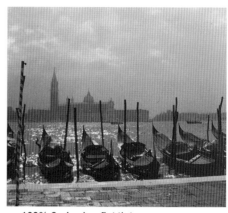

100% 2nd color: flat tint
✤ 100% Black: halftone

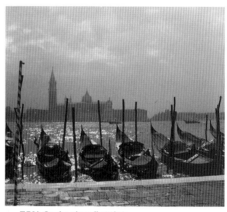

75% 2nd color: flat tint
✤ 100% Black: halftone

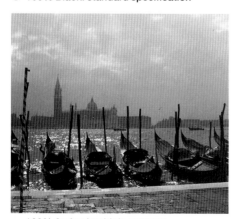

100% 2nd color: high contrast
✤ 100% Black: high contrast

100% 2nd color: low contrast
✤ 100% Black: low contrast

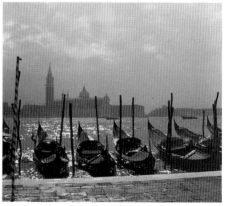

50% 2nd color: flat tint
✤ 100% Black: halftone

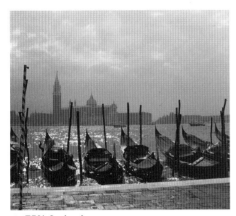

75% 2nd color
✤ 100% Black

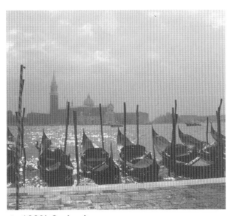

100% 2nd color
✤ 75% Black

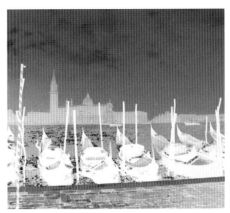

2nd color: negative halftone
✤ Black: negative halftone

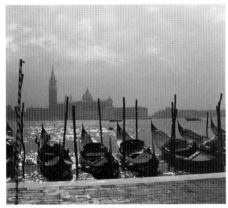

50% 2nd color
✤ 100% Black

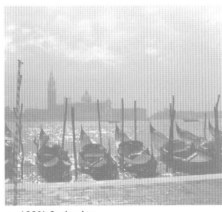

100% 2nd color
✤ 50% Black

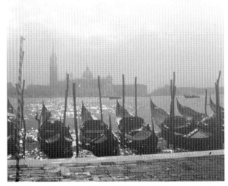

2nd color: from top 100% to 0% gradated
✤ Black: from top 0% to 100% gradated

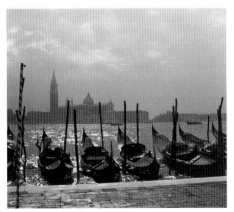

25% 2nd color
✤ 100% Black

100% 2nd color
✤ 25% Black

Image for use with color acetate

Orange

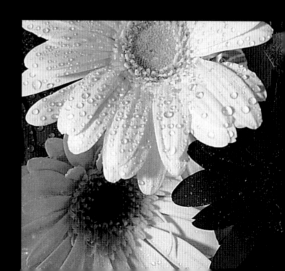

duotones

Burnt orange **Fluorescent orange** **Orange**

✦ **Burnt orange+black** duotone

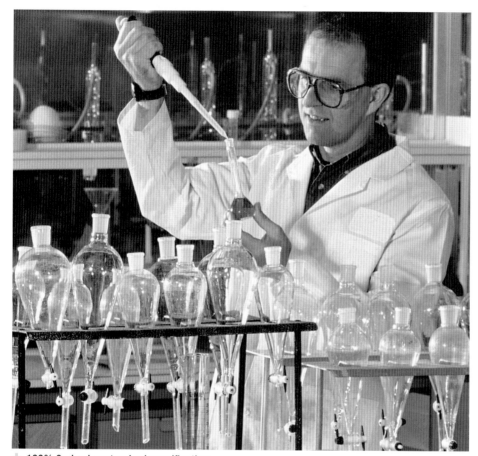

✦ 100% 2nd color: standard specification
✤ 100% Black: standard specification

✦ 100% 2nd color: flat tint
✤ 100% Black: halftone

✦ 75% 2nd color: flat tint
✤ 100% Black: halftone

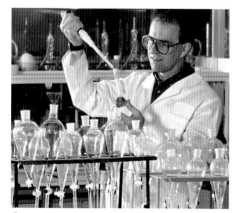

✦ 100% 2nd color: high contrast
✤ 100% Black: high contrast

✦ 100% 2nd color: low contrast
✤ 100% Black: low contrast

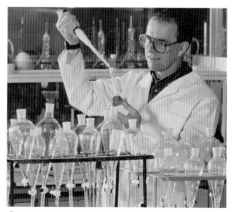

✦ 50% 2nd color: flat tint
✤ 100% Black: halftone

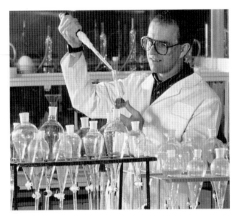

75% 2nd color
100% Black

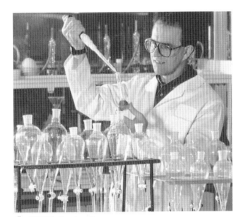

100% 2nd color
75% Black

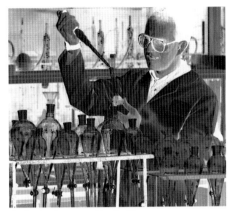

2nd color: negative halftone
Black: negative halftone

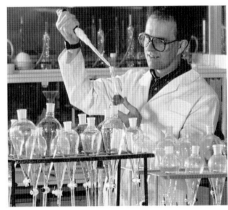

50% 2nd color
100% Black

100% 2nd color
50% Black

2nd color: from top 100% to 0% gradated
Black: from top 0% to 100% gradated

25% 2nd color
100% Black

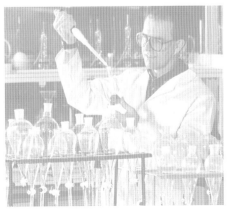

100% 2nd color
25% Black

Image for use with color acetate

✥ **Fluorescent orange+black** duotone

✥ 100% 2nd color: standard specification
✤ 100% Black: standard specification

✥ 100% 2nd color: flat tint
✤ 100% Black: halftone

✥ 75% 2nd color: flat tint
✤ 100% Black: halftone

✥ 100% 2nd color: high contrast
✤ 100% Black: high contrast

✥ 100% 2nd color: low contrast
✤ 100% Black: low contrast

✥ 50% 2nd color: flat tint
✤ 100% Black: halftone

✤ 75% 2nd color
✤ 100% Black

✤ 100% 2nd color
✤ 75% Black

✤ 2nd color: negative halftone
✤ Black: negative halftone

✤ 50% 2nd color
✤ 100% Black

✤ 100% 2nd color
✤ 50% Black

✤ 2nd color: from top 100% to 0% gradated
✤ Black: from top 0% to 100% gradated

✤ 25% 2nd color
✤ 100% Black

✤ 100% 2nd color
✤ 25% Black

Image for use with color acetate

✛ **Orange**+**black** duotone

✛ 100% 2nd color: standard specification
✛ 100% Black: standard specification

✛ 100% 2nd color: flat tint
✛ 100% Black: halftone

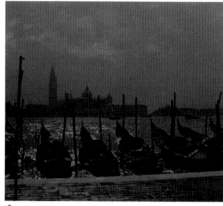

✛ 75% 2nd color: flat tint
✛ 100% Black: halftone

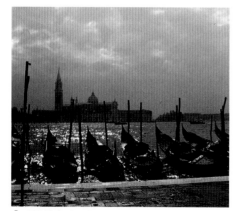

✛ 100% 2nd color: high contrast
✛ 100% Black: high contrast

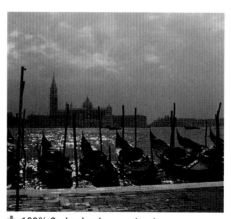

✛ 100% 2nd color: low contrast
✛ 100% Black: low contrast

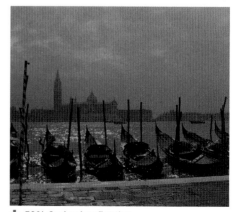

✛ 50% 2nd color: flat tint
✛ 100% Black: halftone

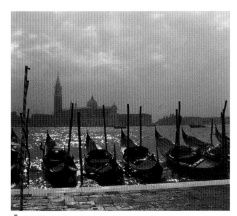

✛ 75% 2nd color
❖ 100% Black

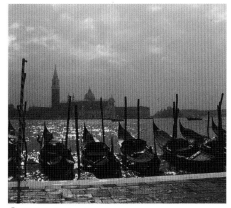

✛ 100% 2nd color
❖ 75% Black

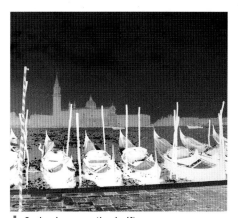

✛ 2nd color: negative halftone
❖ Black: negative halftone

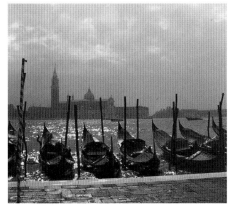

✛ 50% 2nd color
❖ 100% Black

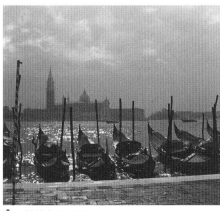

✛ 100% 2nd color
❖ 50% Black

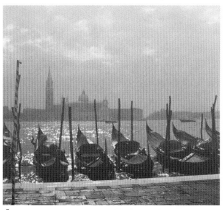

✛ 2nd color: from top 100% to 0% gradated
❖ Black: from top 0% to 100% gradated

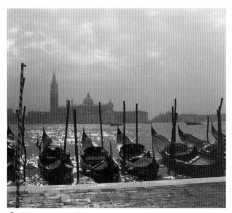

✛ 25% 2nd color
❖ 100% Black

✛ 100% 2nd color
❖ 25% Black

Image for use with color acetate

Red

duotones

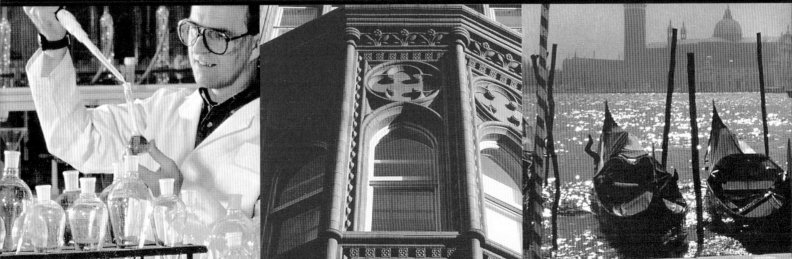

Red Rubine red Brick red

✤ **Red**+**black** duotone

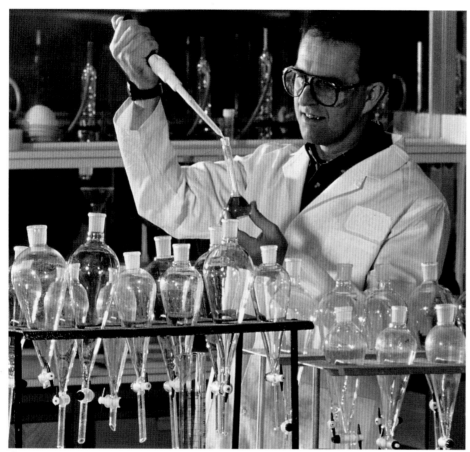

✤ 100% 2nd color: standard specification
✤ 100% Black: standard specification

✤ 100% 2nd color: flat tint
✤ 100% Black: halftone

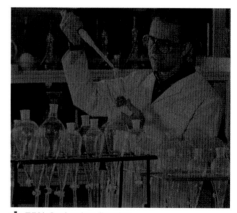

✤ 75% 2nd color: flat tint
✤ 100% Black: halftone

✤ 100% 2nd color: high contrast
✤ 100% Black: high contrast

✤ 100% 2nd color: low contrast
✤ 100% Black: low contrast

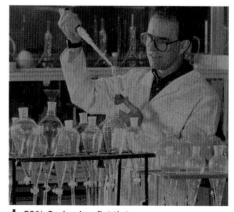

✤ 50% 2nd color: flat tint
✤ 100% Black: halftone

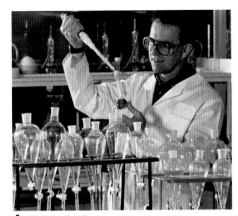

✤ 75% 2nd color
✤ 100% Black

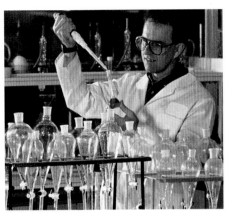

✤ 100% 2nd color
✤ 75% Black

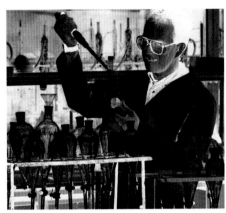

✤ 2nd color: negative halftone
✤ Black: negative halftone

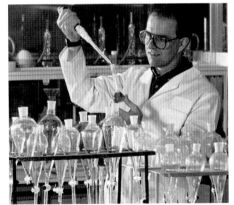

✤ 50% 2nd color
✤ 100% Black

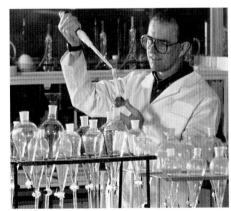

✤ 100% 2nd color
✤ 50% Black

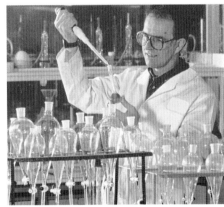

✤ 2nd color: from top 100% to 0% gradated
✤ Black: from top 0% to 100% gradated

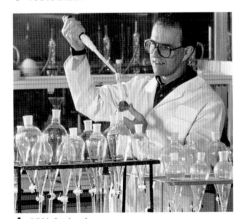

✤ 25% 2nd color
✤ 100% Black

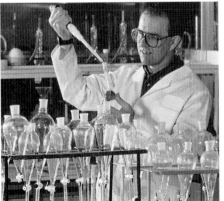
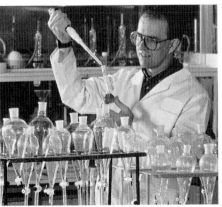

✤ 100% 2nd color
✤ 25% Black

Image for use with color acetate

✚ **Rubine red**+**black** *duotone*

✤ 100% 2nd color: standard specification
✤ 100% Black: standard specification

✤ 100% 2nd color: flat tint
✤ 100% Black: halftone

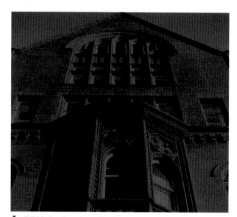

✤ 75% 2nd color: flat tint
✤ 100% Black: halftone

✤ 100% 2nd color: high contrast
✤ 100% Black: high contrast

✤ 100% 2nd color: low contrast
✤ 100% Black: low contrast

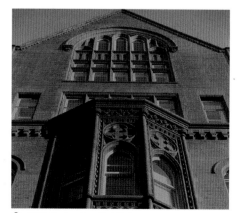

✤ 50% 2nd color: flat tint
✤ 100% Black: halftone

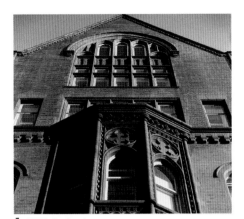

✤ 75% 2nd color
✤ 100% Black

✤ 100% 2nd color
✤ 75% Black

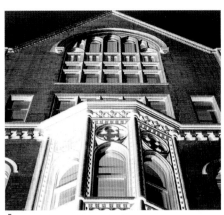

✤ 2nd color: negative halftone
✤ Black: negative halftone

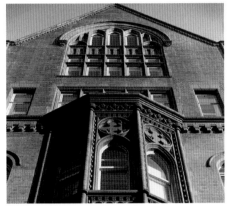

✤ 50% 2nd color
✤ 100% Black

✤ 100% 2nd color
✤ 50% Black

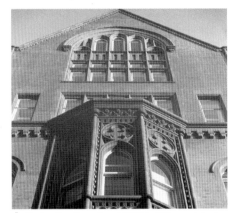

✤ 2nd color: from top 100% to 0% gradated
✤ Black: from top 0% to 100% gradated

✤ 25% 2nd color
✤ 100% Black

✤ 100% 2nd color
✤ 25% Black

Image for use with color acetate

✛ **Brick red+black** duotone

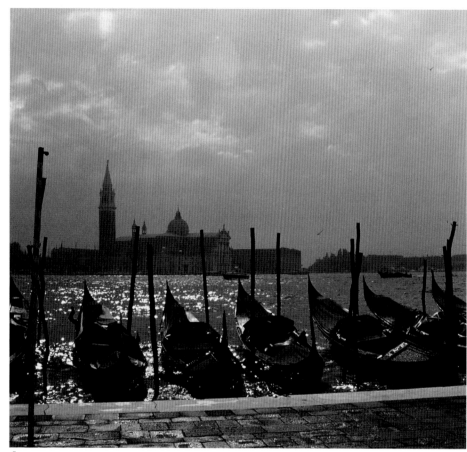

✛ 100% 2nd color: standard specification
✛ 100% Black: standard specification

✛ 100% 2nd color: flat tint
✛ 100% Black: halftone

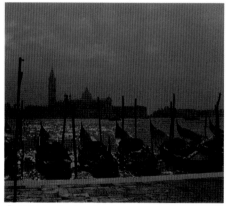

✛ 75% 2nd color: flat tint
✛ 100% Black: halftone

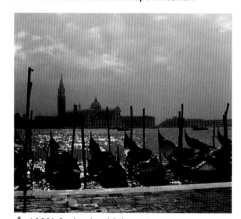

✛ 100% 2nd color: high contrast
✛ 100% Black: high contrast

✛ 100% 2nd color: low contrast
✛ 100% Black: low contrast

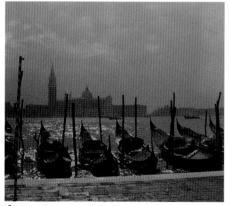

✛ 50% 2nd color: flat tint
✛ 100% Black: halftone

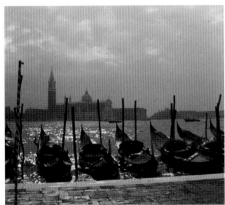

✤ 75% 2nd color
✤ 100% Black

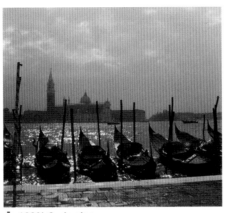

✤ 100% 2nd color
✤ 75% Black

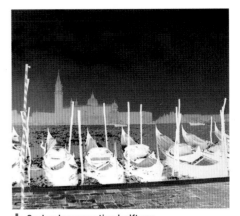

✤ 2nd color: negative halftone
✤ Black: negative halftone

✤ 50% 2nd color
✤ 100% Black

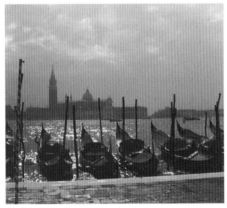

✤ 100% 2nd color
✤ 50% Black

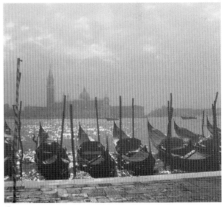

✤ 2nd color: from top 100% to 0% gradated
✤ Black: from top 0% to 100% gradated

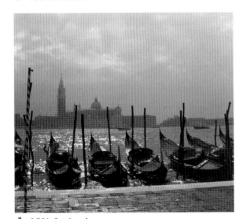

✤ 25% 2nd color
✤ 100% Black

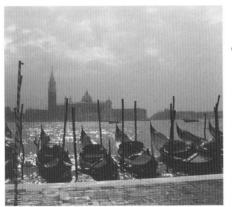

✤ 100% 2nd color
✤ 25% Black

Image for use with color acetate

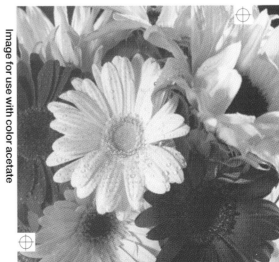

Pink

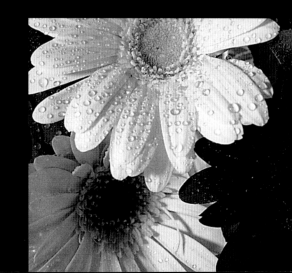

duotones

Pale pink **Salmon** **Pink**

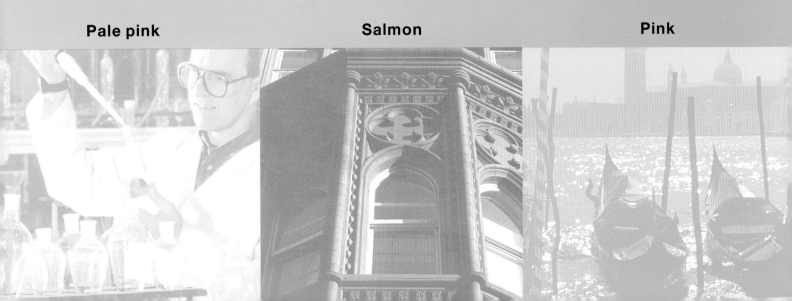

✛ **Pale pink**+**black** duotone

✛ 100% 2nd color: standard specification
✛ 100% Black: standard specification

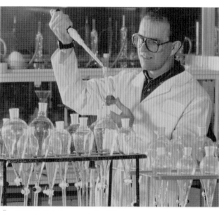

✛ 100% 2nd color: flat tint
✛ 100% Black: halftone

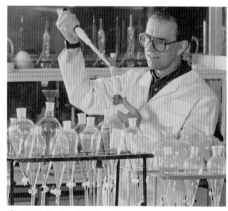

✛ 75% 2nd color: flat tint
✛ 100% Black: halftone

✛ 100% 2nd color: high contrast
✛ 100% Black: high contrast

✛ 100% 2nd color: low contrast
✛ 100% Black: low contrast

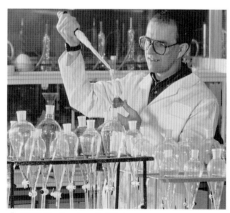

✛ 50% 2nd color: flat tint
✛ 100% Black: halftone

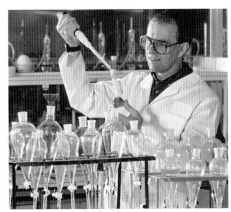

75% 2nd color
✚ 100% Black

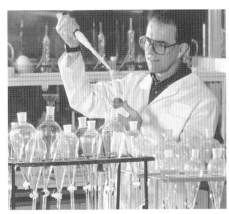

100% 2nd color
✚ 75% Black

2nd color: negative halftone
✚ Black: negative halftone

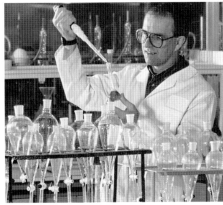

50% 2nd color
✚ 100% Black

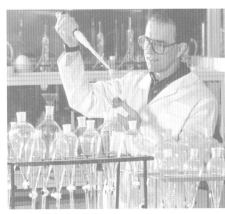

100% 2nd color
✚ 50% Black

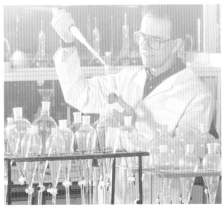

2nd color: from top 100% to 0% gradated
✚ Black: from top 0% to 100% gradated

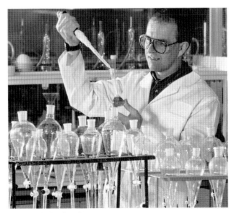

25% 2nd color
✚ 100% Black

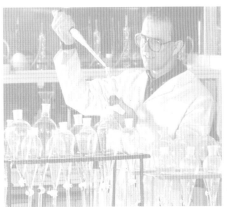

100% 2nd color
✚ 25% Black

Image for use with color acetate

✚ **Salmon**+**black** duotone

✚ 100% 2nd color: standard specification
✚ 100% Black: standard specification

✚ 100% 2nd color: flat tint
✚ 100% Black: halftone

✚ 75% 2nd color: flat tint
✚ 100% Black: halftone

✚ 100% 2nd color: high contrast
✚ 100% Black: high contrast

✚ 100% 2nd color: low contrast
✚ 100% Black: low contrast

✚ 50% 2nd color: flat tint
✚ 100% Black: halftone

✤ 75% 2nd color
✤ 100% Black

✤ 100% 2nd color
✤ 75% Black

✤ 2nd color: negative halftone
✤ Black: negative halftone

✤ 50% 2nd color
✤ 100% Black

✤ 100% 2nd color
✤ 50% Black

✤ 2nd color: from top 100% to 0% gradated
✤ Black: from top 0% to 100% gradated

✤ 25% 2nd color
✤ 100% Black

✤ 100% 2nd color
✤ 25% Black

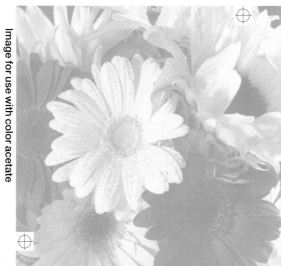

Image for use with color acetate

✛ **Pink+black** duotone

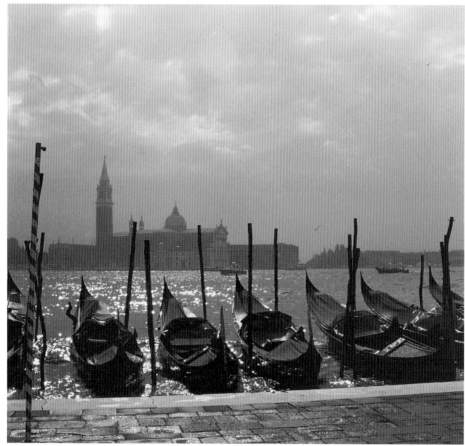

✛ 100% 2nd color: standard specification
✛ 100% Black: standard specification

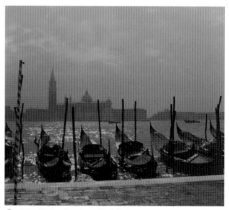

✛ 100% 2nd color: flat tint
✛ 100% Black: halftone

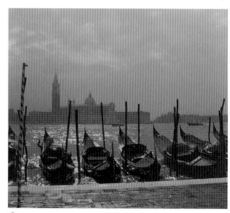

✛ 75% 2nd color: flat tint
✛ 100% Black: halftone

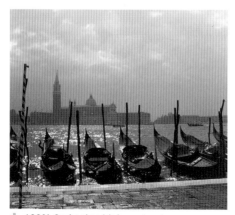

✛ 100% 2nd color: high contrast
✛ 100% Black: high contrast

✛ 100% 2nd color: low contrast
✛ 100% Black: low contrast

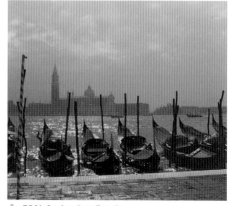

✛ 50% 2nd color: flat tint
✛ 100% Black: halftone

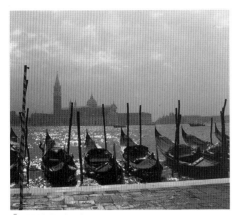

✣ 75% 2nd color
✤ 100% Black

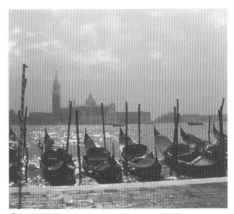

✣ 100% 2nd color
✤ 75% Black

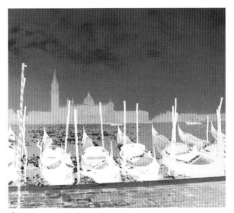

✣ 2nd color: negative halftone
✤ Black: negative halftone

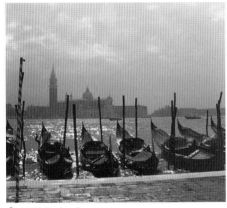

✣ 50% 2nd color
✤ 100% Black

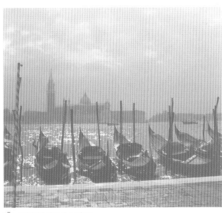

✣ 100% 2nd color
✤ 50% Black

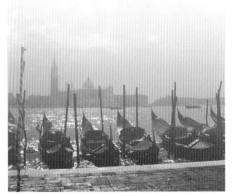

✣ 2nd color: from top 100% to 0% gradated
✤ Black: from top 0% to 100% gradated

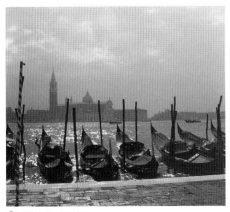

✣ 25% 2nd color
✤ 100% Black

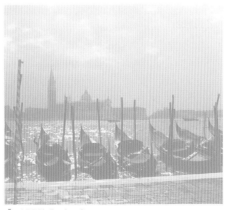

✣ 100% 2nd color
✤ 25% Black

Image for use with color acetate

Purple

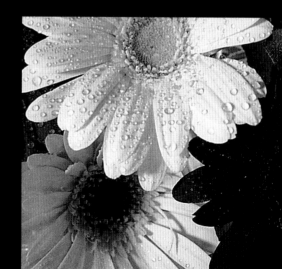

duotones

Cerise Purple Plum

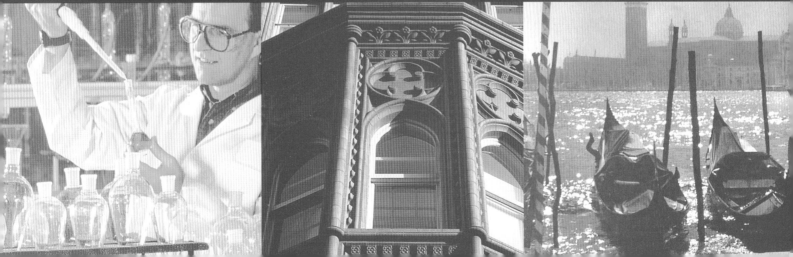

✛ **Cerise**+**black** duotone

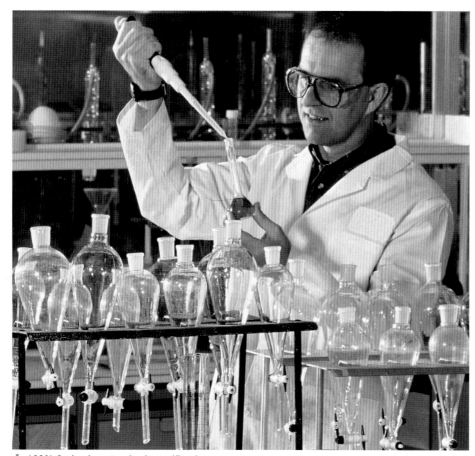

✛ 100% 2nd color: standard specification
✛ 100% Black: standard specification

✛ 100% 2nd color: flat tint
✛ 100% Black: halftone

✛ 75% 2nd color: flat tint
✛ 100% Black: halftone

✛ 100% 2nd color: high contrast
✛ 100% Black: high contrast

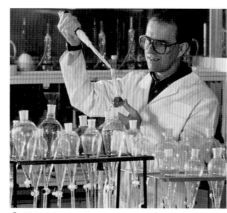

✛ 100% 2nd color: low contrast
✛ 100% Black: low contrast

✛ 50% 2nd color: flat tint
✛ 100% Black: halftone

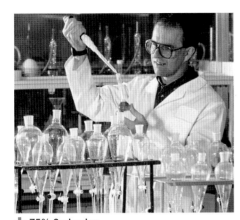

✤ 75% 2nd color
✤ 100% Black

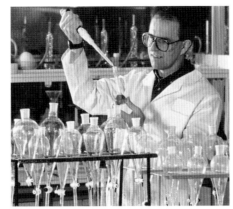

✤ 100% 2nd color
✤ 75% Black

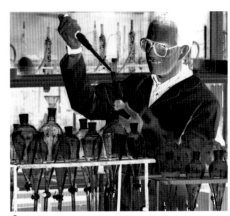

✤ 2nd color: negative halftone
✤ Black: negative halftone

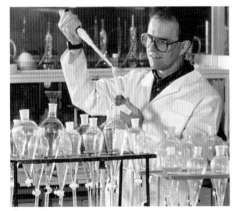

✤ 50% 2nd color
✤ 100% Black

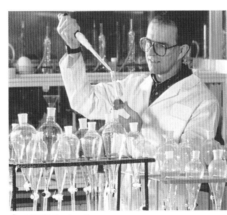

✤ 100% 2nd color
✤ 50% Black

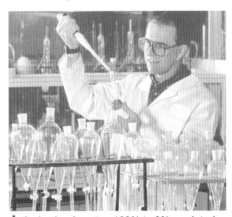

✤ 2nd color: from top 100% to 0% gradated
✤ Black: from top 0% to 100% gradated

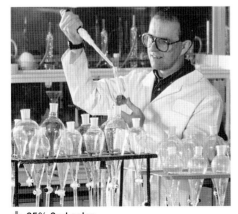

✤ 25% 2nd color
✤ 100% Black

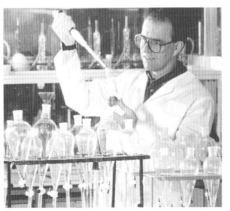

✤ 100% 2nd color
✤ 25% Black

Image for use with color acetate

✛ **Purple**+**black** duotone

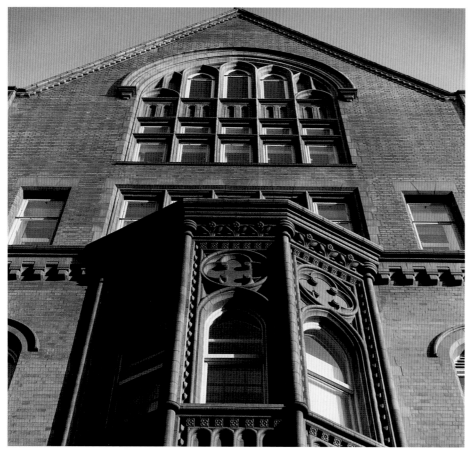

✛ 100% 2nd color: standard specification
✛ 100% Black: standard specification

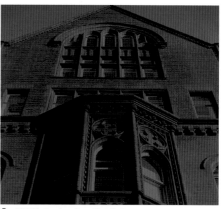

✛ 100% 2nd color: flat tint
✛ 100% Black: halftone

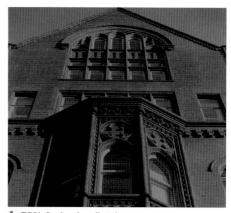

✛ 75% 2nd color: flat tint
✛ 100% Black: halftone

✛ 100% 2nd color: high contrast
✛ 100% Black: high contrast

✛ 100% 2nd color: low contrast
✛ 100% Black: low contrast

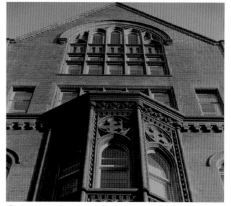

✛ 50% 2nd color: flat tint
✛ 100% Black: halftone

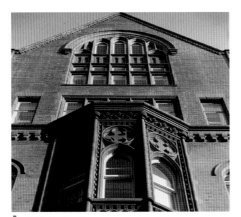

✤ 75% 2nd color
❖ 100% Black

✤ 100% 2nd color
❖ 75% Black

✤ 2nd color: negative halftone
❖ Black: negative halftone

✤ 50% 2nd color
❖ 100% Black

✤ 100% 2nd color
❖ 50% Black

✤ 2nd color: from top 100% to 0% gradated
❖ Black: from top 0% to 100% gradated

✤ 25% 2nd color
❖ 100% Black

✤ 100% 2nd color
❖ 25% Black

Image for use with color acetate

✛ **Plum**+**black** duotone

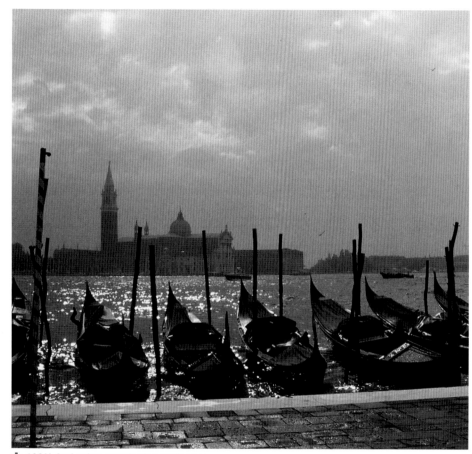

✛ 100% 2nd color: standard specification
✛ 100% Black: standard specification

✛ 100% 2nd color: flat tint
✛ 100% Black: halftone

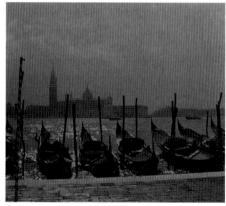

✛ 75% 2nd color: flat tint
✛ 100% Black: halftone

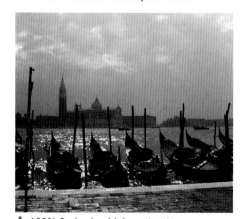

✛ 100% 2nd color: high contrast
✛ 100% Black: high contrast

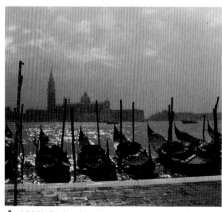

✛ 100% 2nd color: low contrast
✛ 100% Black: low contrast

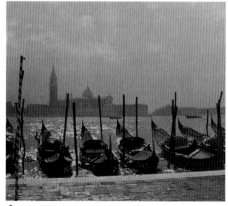

✛ 50% 2nd color: flat tint
✛ 100% Black: halftone

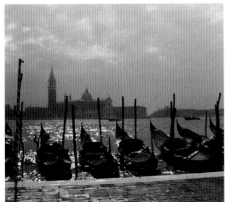

✛ 75% 2nd color
✛ 100% Black

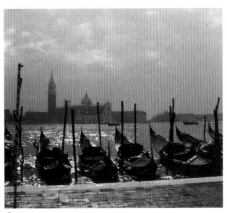

✛ 100% 2nd color
✛ 75% Black

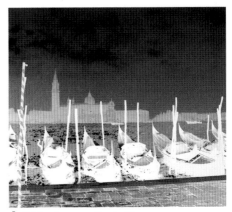

✛ 2nd color: negative halftone
✛ Black: negative halftone

✛ 50% 2nd color
✛ 100% Black

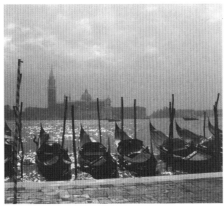

✛ 100% 2nd color
✛ 50% Black

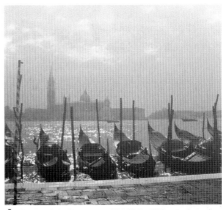

✛ 2nd color: from top 100% to 0% gradated
✛ Black: from top 0% to 100% gradated

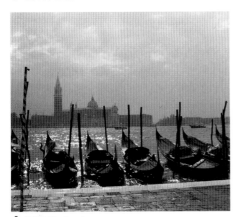

✛ 25% 2nd color
✛ 100% Black

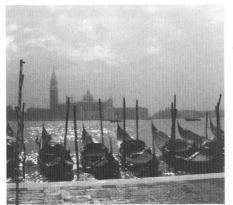

✛ 100% 2nd color
✛ 25% Black

Image for use with color acetate

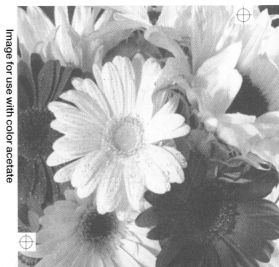

Violet

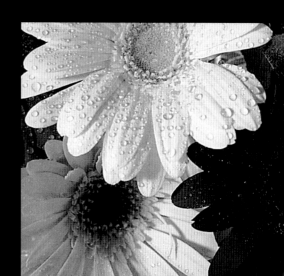

es

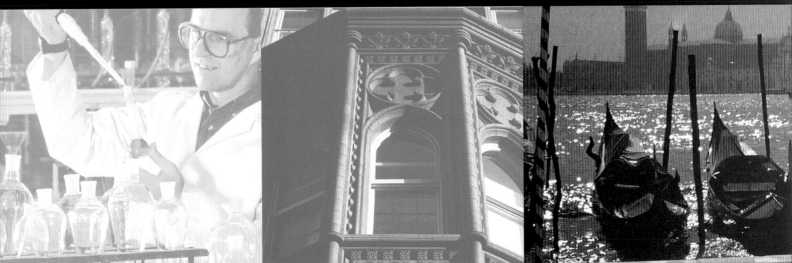

✛ **Gray violet+black** duotone

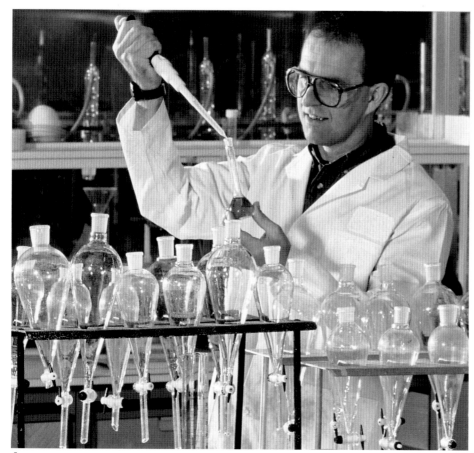

✛ 100% 2nd color: standard specification
✛ 100% Black: standard specification

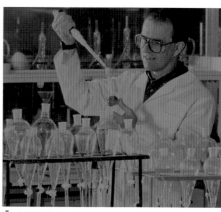

✛ 100% 2nd color: flat tint
✛ 100% Black: halftone

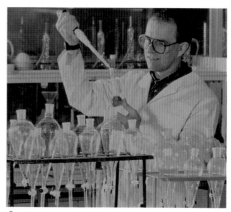

✛ 75% 2nd color: flat tint
✛ 100% Black: halftone

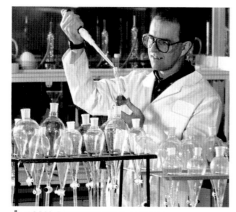

✛ 100% 2nd color: high contrast
✛ 100% Black: high contrast

✛ 100% 2nd color: low contrast
✛ 100% Black: low contrast

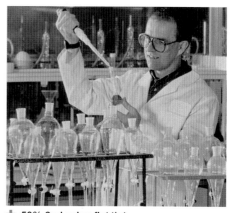

✛ 50% 2nd color: flat tint
✛ 100% Black: halftone

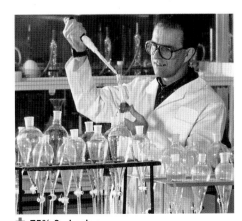

✛ 75% 2nd color
❖ 100% Black

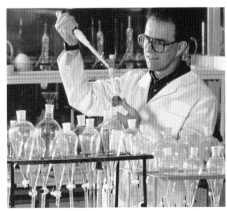

✛ 100% 2nd color
❖ 75% Black

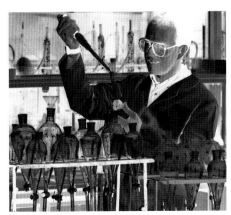

✛ 2nd color: negative halftone
❖ Black: negative halftone

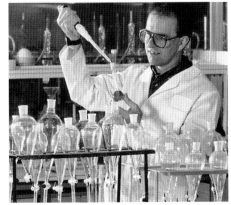

✛ 50% 2nd color
❖ 100% Black

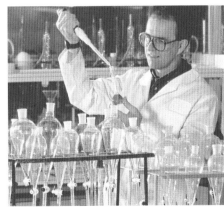

✛ 100% 2nd color
❖ 50% Black

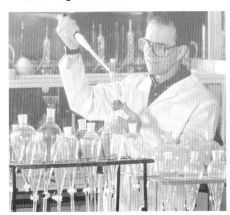

✛ 2nd color: from top 100% to 0% gradated
❖ Black: from top 0% to 100% gradated

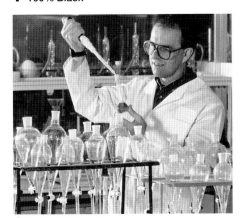

✛ 25% 2nd color
❖ 100% Black

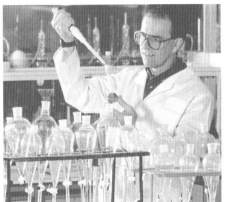

✛ 100% 2nd color
❖ 25% Black

Image for use with color acetate

✚ **Lavender+black** duotone

✚ 100% 2nd color: standard specification
✚ 100% Black: standard specification

✚ 100% 2nd color: flat tint
✚ 100% Black: halftone

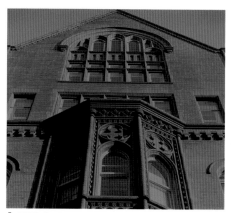

✚ 75% 2nd color: flat tint
✚ 100% Black: halftone

✚ 100% 2nd color: high contrast
✚ 100% Black: high contrast

✚ 100% 2nd color: low contrast
✚ 100% Black: low contrast

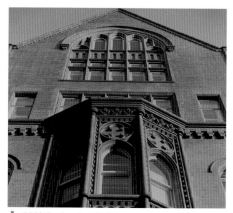

✚ 50% 2nd color: flat tint
✚ 100% Black: halftone

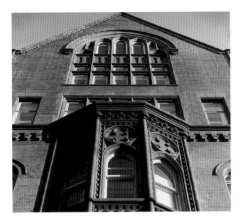

✛ 75% 2nd color
✛ 100% Black

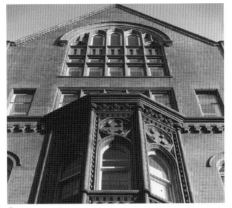

✛ 100% 2nd color
✛ 75% Black

✛ 2nd color: negative halftone
✛ Black: negative halftone

✛ 50% 2nd color
✛ 100% Black

✛ 100% 2nd color
✛ 50% Black

✛ 2nd color: from top 100% to 0% gradated
✛ Black: from top 0% to 100% gradated

✛ 25% 2nd color
✛ 100% Black

✛ 100% 2nd color
✛ 25% Black

Image for use with color acetate

✚ **Violet+black** *duotone*

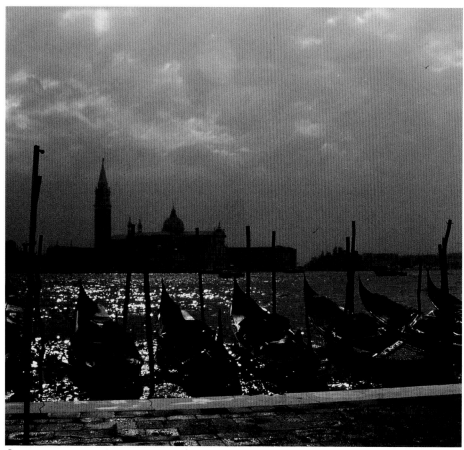

✚ 100% 2nd color: standard specification
✚ 100% Black: standard specification

✚ 100% 2nd color: flat tint
✚ 100% Black: halftone

✚ 75% 2nd color: flat tint
✚ 100% Black: halftone

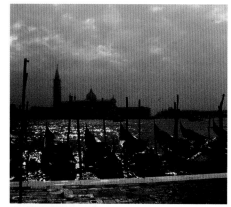

✚ 100% 2nd color: high contrast
✚ 100% Black: high contrast

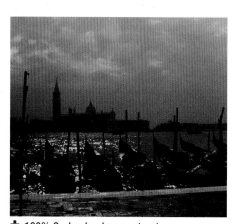

✚ 100% 2nd color: low contrast
✚ 100% Black: low contrast

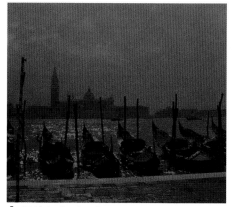

✚ 50% 2nd color: flat tint
✚ 100% Black: halftone

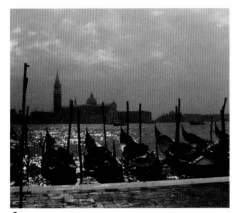
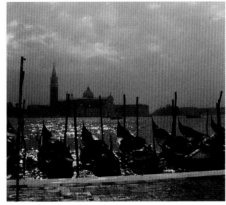
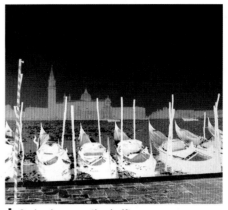

✛ 75% 2nd color
✛ 100% Black

✛ 100% 2nd color
✛ 75% Black

✛ 2nd color: negative halftone
✛ Black: negative halftone

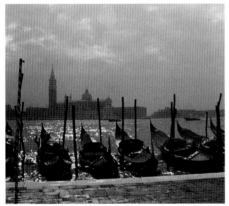
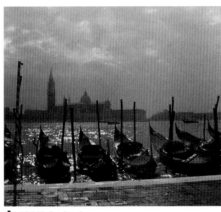
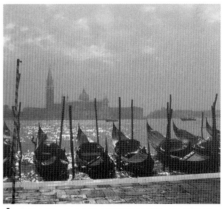

✛ 50% 2nd color
✛ 100% Black

✛ 100% 2nd color
✛ 50% Black

✛ 2nd color: from top 100% to 0% gradated
✛ Black: from top 0% to 100% gradated

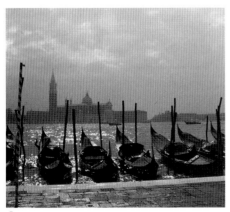
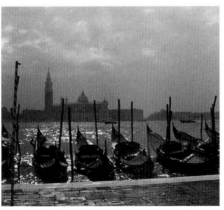

✛ 25% 2nd color
✛ 100% Black

✛ 100% 2nd color
✛ 25% Black

Image for use with color acetate

Light
blue

duotones

Pale blue

Lilac

Aqua blue

✣ **Pale blue**+**black** duotone

✣ 100% 2nd color: standard specification
✤ 100% Black: standard specification

✣ 100% 2nd color: flat tint
✤ 100% Black: halftone

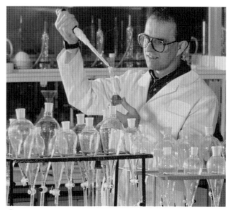

✣ 75% 2nd color: flat tint
✤ 100% Black: halftone

✣ 100% 2nd color: high contrast
✤ 100% Black: high contrast

✣ 100% 2nd color: low contrast
✤ 100% Black: low contrast

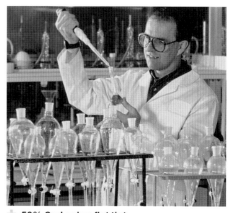

✣ 50% 2nd color: flat tint
✤ 100% Black: halftone

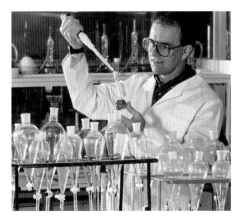

✛ 75% 2nd color
✛ 100% Black

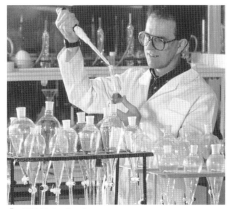

✛ 100% 2nd color
✛ 75% Black

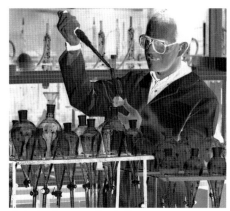

✛ 2nd color: negative halftone
✛ Black: negative halftone

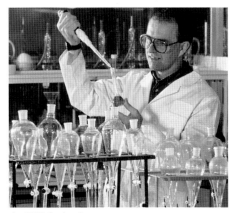

✛ 50% 2nd color
✛ 100% Black

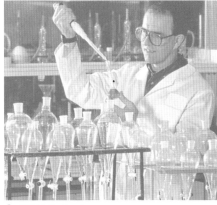

✛ 100% 2nd color
✛ 50% Black

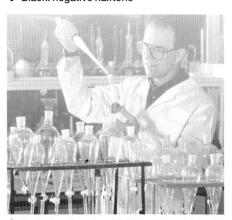

✛ 2nd color: from top 100% to 0% gradated
✛ Black: from top 0% to 100% gradated

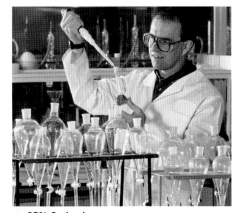

✛ 25% 2nd color
✛ 100% Black

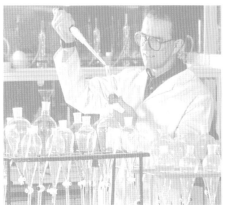

✛ 100% 2nd color
✛ 25% Black

Image for use with color acetate

✤ **Lilac+black** duotone

✤ 100% 2nd color: standard specification
✤ 100% Black: standard specification

✤ 100% 2nd color: flat tint
✤ 100% Black: halftone

✤ 75% 2nd color: flat tint
✤ 100% Black: halftone

✤ 100% 2nd color: high contrast
✤ 100% Black: high contrast

✤ 100% 2nd color: low contrast
✤ 100% Black: low contrast

✤ 50% 2nd color: flat tint
✤ 100% Black: halftone

✢ 75% 2nd color
✤ 100% Black

✢ 100% 2nd color
✤ 75% Black

✢ 2nd color: negative halftone
✤ Black: negative halftone

✢ 50% 2nd color
✤ 100% Black

✢ 100% 2nd color
✤ 50% Black

✢ 2nd color: from top 100% to 0% gradated
✤ Black: from top 0% to 100% gradated

✢ 25% 2nd color
✤ 100% Black

✢ 100% 2nd color
✤ 25% Black

Image for use with color acetate

✛ **Aqua blue**+**black** duotone

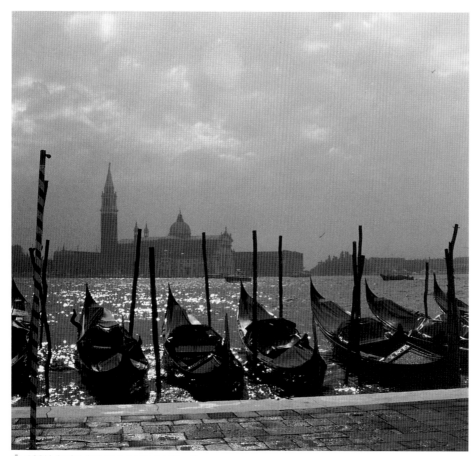

✛ 100% 2nd color: standard specification
✛ 100% Black: standard specification

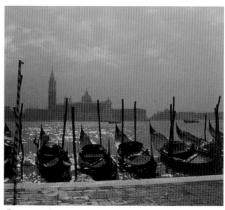

✛ 100% 2nd color: flat tint
✛ 100% Black: halftone

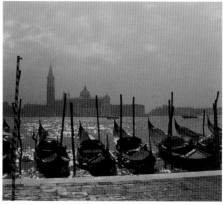

✛ 75% 2nd color: flat tint
✛ 100% Black: halftone

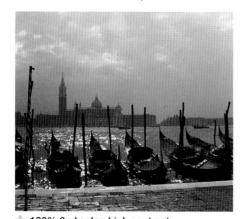

✛ 100% 2nd color: high contrast
✛ 100% Black: high contrast

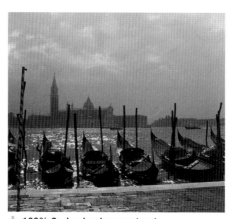

✛ 100% 2nd color: low contrast
✛ 100% Black: low contrast

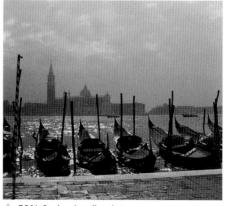

✛ 50% 2nd color: flat tint
✛ 100% Black: halftone

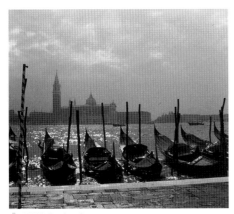

�֍ 75% 2nd color
✤ 100% Black

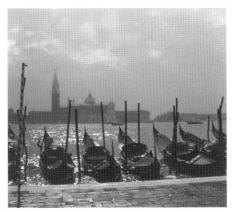

✖ 100% 2nd color
✤ 75% Black

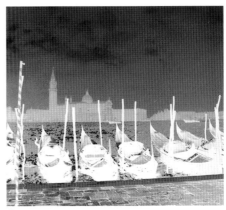

✖ 2nd color: negative halftone
✤ Black: negative halftone

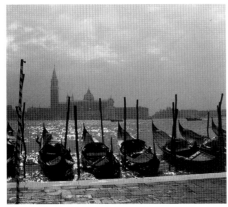

✖ 50% 2nd color
✤ 100% Black

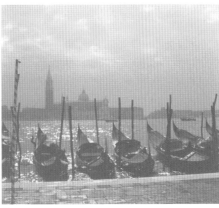

✖ 100% 2nd color
✤ 50% Black

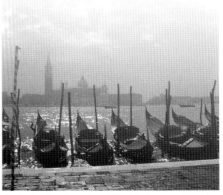

✖ 2nd color: from top 100% to 0% gradated
✤ Black: from top 0% to 100% gradated

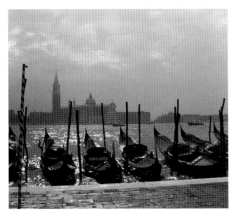

✖ 25% 2nd color
✤ 100% Black

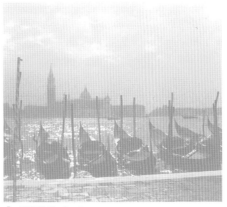

✖ 100% 2nd color
✤ 25% Black

Image for use with color acetate

Blue

duotones

Sky blue **Teal** **Reflex blue**

✛ **Sky blue**+**black** duotone

✛ 100% 2nd color: standard specification
✚ 100% Black: standard specification

✛ 100% 2nd color: flat tint
✚ 100% Black: halftone

✛ 75% 2nd color: flat tint
✚ 100% Black: halftone

✛ 100% 2nd color: high contrast
✚ 100% Black: high contrast

✛ 100% 2nd color: low contrast
✚ 100% Black: low contrast

✛ 50% 2nd color: flat tint
✚ 100% Black: halftone

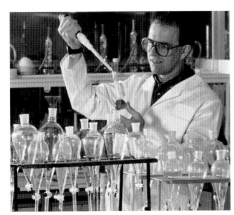

✤ 75% 2nd color
✤ 100% Black

✤ 100% 2nd color
✤ 75% Black

✤ 2nd color: negative halftone
✤ Black: negative halftone

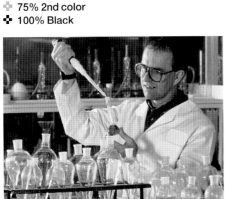

✤ 50% 2nd color
✤ 100% Black

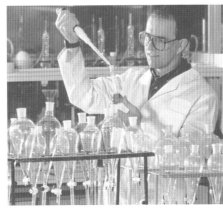

✤ 100% 2nd color
✤ 50% Black

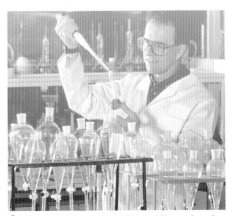

✤ 2nd color: from top 100% to 0% gradated
✤ Black: from top 0% to 100% gradated

✤ 25% 2nd color
✤ 100% Black

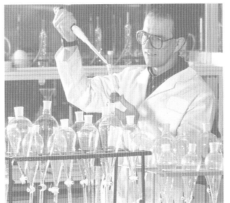

✤ 100% 2nd color
✤ 25% Black

Image for use with color acetate

✛ **Teal**+**black** duotone

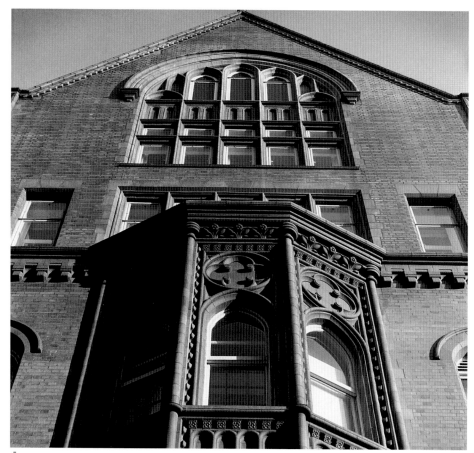

✛ 100% 2nd color: standard specification
✛ 100% Black: standard specification

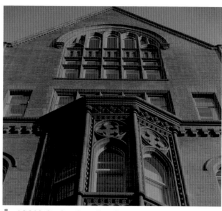

✛ 100% 2nd color: flat tint
✛ 100% Black: halftone

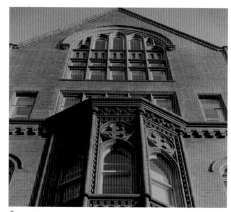

✛ 75% 2nd color: flat tint
✛ 100% Black: halftone

✛ 100% 2nd color: high contrast
✛ 100% Black: high contrast

✛ 100% 2nd color: low contrast
✛ 100% Black: low contrast

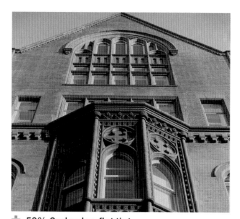

✛ 50% 2nd color: flat tint
✛ 100% Black: halftone

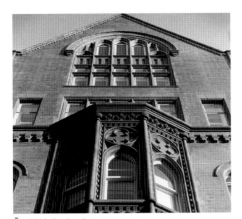

✤ 75% 2nd color
✤ 100% Black

✤ 100% 2nd color
✤ 75% Black

✤ 2nd color: negative halftone
✤ Black: negative halftone

✤ 50% 2nd color
✤ 100% Black

✤ 100% 2nd color
✤ 50% Black

✤ 2nd color: from top 100% to 0% gradated
✤ Black: from top 0% to 100% gradated

✤ 25% 2nd color
✤ 100% Black

✤ 100% 2nd color
✤ 25% Black

Image for use with color acetate

✤ **Reflex blue**+**black** duotone

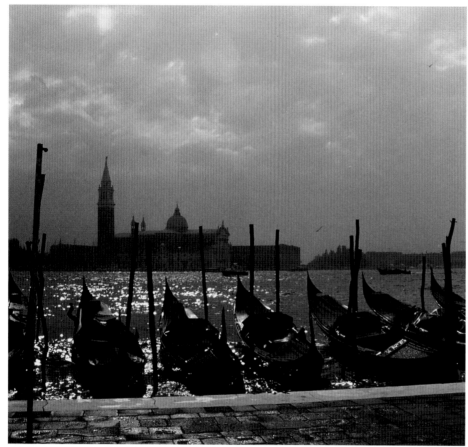

✤ 100% 2nd color: standard specification
✤ 100% Black: standard specification

✤ 100% 2nd color: flat tint
✤ 100% Black: halftone

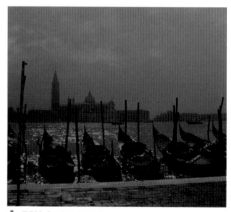

✤ 75% 2nd color: flat tint
✤ 100% Black: halftone

✤ 100% 2nd color: high contrast
✤ 100% Black: high contrast

✤ 100% 2nd color: low contrast
✤ 100% Black: low contrast

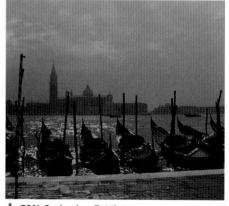

✤ 50% 2nd color: flat tint
✤ 100% Black: halftone

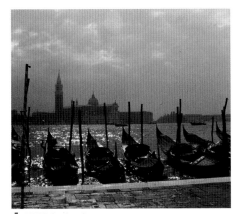

✣ 75% 2nd color
✣ 100% Black

✣ 100% 2nd color
✣ 75% Black

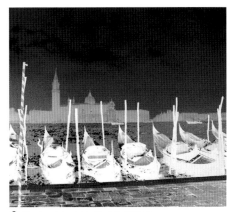

✣ 2nd color: negative halftone
✣ Black: negative halftone

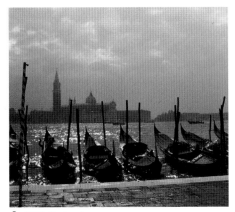

✣ 50% 2nd color
✣ 100% Black

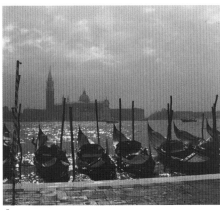

✣ 100% 2nd color
✣ 50% Black

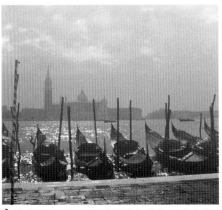

✣ 2nd color: from top 100% to 0% gradated
✣ Black: from top 0% to 100% gradated

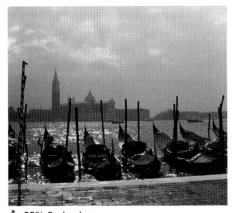

✣ 25% 2nd color
✣ 100% Black

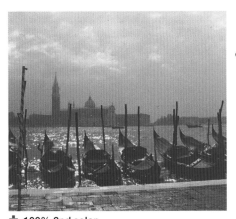

✣ 100% 2nd color
✣ 25% Black

Image for use with color acetate

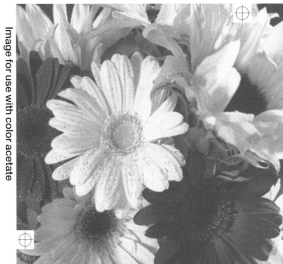

Blue
green

duotones

Turquoise **Viridian** **Emerald**

✛ **Turquoise**+**black** duotone

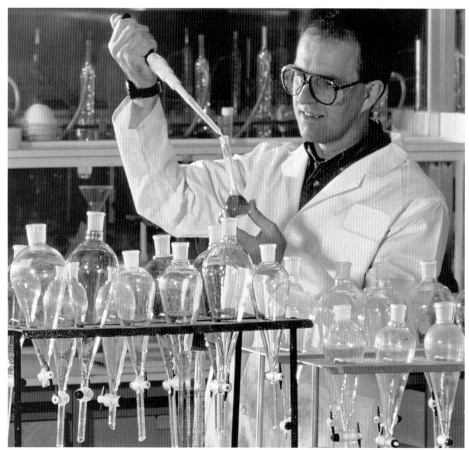

✛ 100% 2nd color: standard specification
✛ 100% Black: standard specification

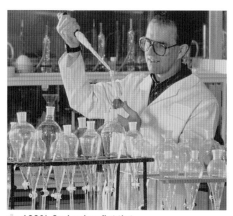

✛ 100% 2nd color: flat tint
✛ 100% Black: halftone

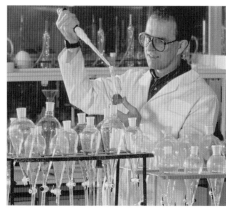

✛ 75% 2nd color: flat tint
✛ 100% Black: halftone

✛ 100% 2nd color: high contrast
✛ 100% Black: high contrast

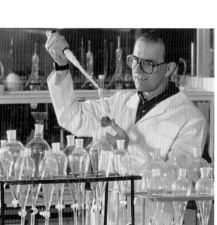
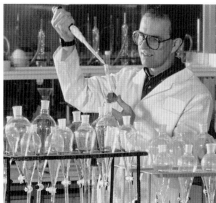

✛ 100% 2nd color: low contrast
✛ 100% Black: low contrast

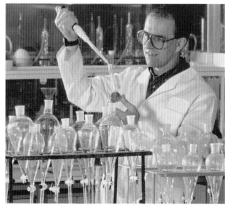

✛ 50% 2nd color: flat tint
✛ 100% Black: halftone

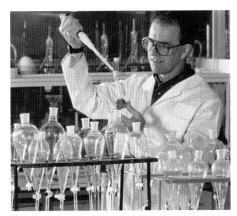

75% 2nd color
100% Black

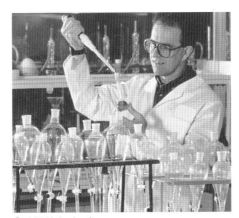

100% 2nd color
75% Black

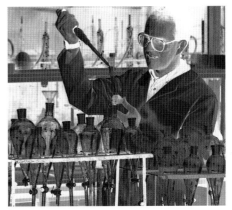

2nd color: negative halftone
Black: negative halftone

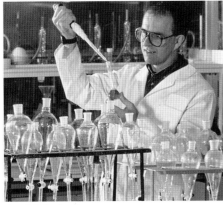

50% 2nd color
100% Black

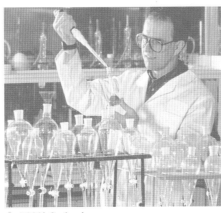

100% 2nd color
50% Black

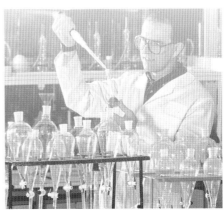

2nd color: from top 100% to 0% gradated
Black: from top 0% to 100% gradated

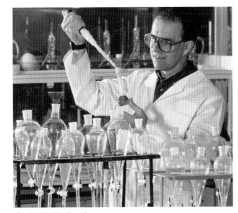

25% 2nd color
100% Black

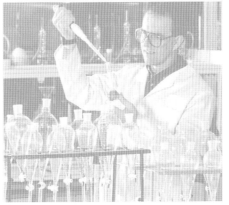

100% 2nd color
25% Black

Image for use with color acetate

✛ **Viridian+black** duotone

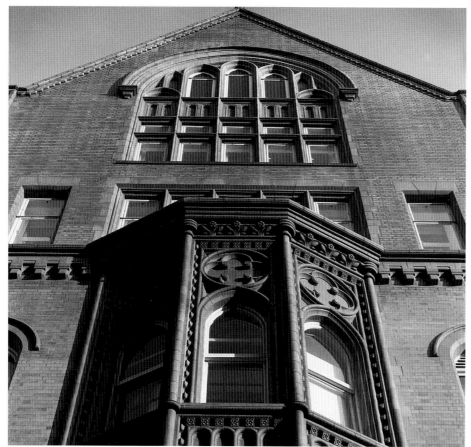

✛ 100% 2nd color: standard specification
✛ 100% Black: standard specification

✛ 100% 2nd color: flat tint
✛ 100% Black: halftone

✛ 75% 2nd color: flat tint
✛ 100% Black: halftone

✛ 100% 2nd color: high contrast
✛ 100% Black: high contrast

✛ 100% 2nd color: low contrast
✛ 100% Black: low contrast

✛ 50% 2nd color: flat tint
✛ 100% Black: halftone

✤ 75% 2nd color
❖ 100% Black

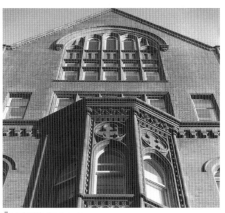

✤ 100% 2nd color
❖ 75% Black

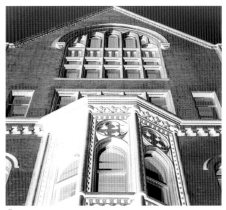

✤ 2nd color: negative halftone
❖ Black: negative halftone

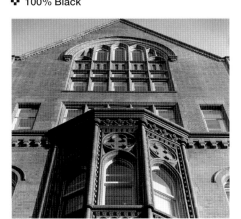

✤ 50% 2nd color
❖ 100% Black

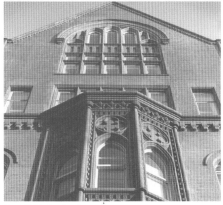

✤ 100% 2nd color
❖ 50% Black

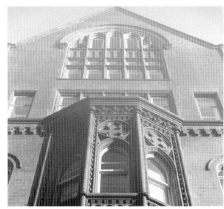

✤ 2nd color: from top 100% to 0% gradated
❖ Black: from top 0% to 100% gradated

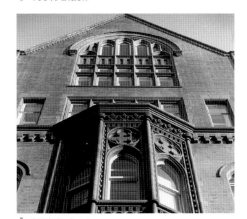

✤ 25% 2nd color
❖ 100% Black

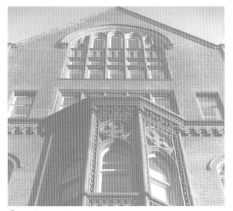

✤ 100% 2nd color
❖ 25% Black

Image for use with color acetate

✚ **Emerald**+**black** duotone

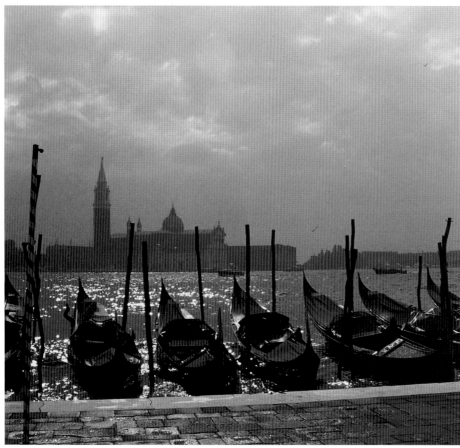

✚ 100% 2nd color: standard specification
✤ 100% Black: standard specification

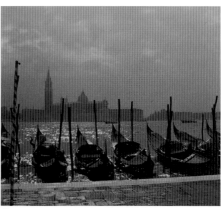

✚ 100% 2nd color: flat tint
✤ 100% Black: halftone

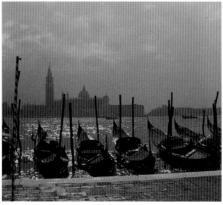

✚ 75% 2nd color: flat tint
✤ 100% Black: halftone

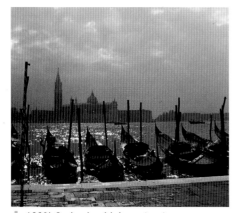

✚ 100% 2nd color: high contrast
✤ 100% Black: high contrast

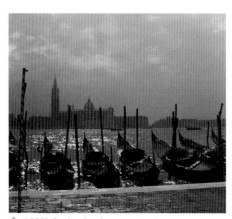

✚ 100% 2nd color: low contrast
✤ 100% Black: low contrast

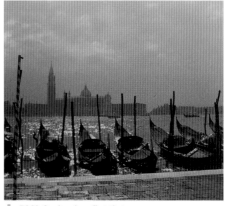

✚ 50% 2nd color: flat tint
✤ 100% Black: halftone

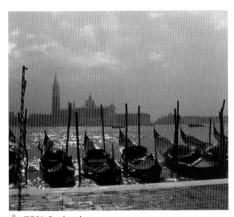

✛ 75% 2nd color
✛ 100% Black

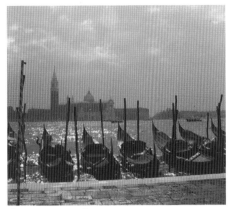

✛ 100% 2nd color
✛ 75% Black

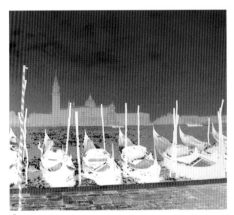

✛ 2nd color: negative halftone
✛ Black: negative halftone

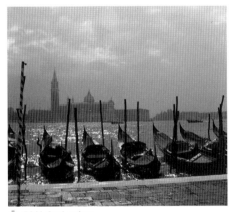

✛ 50% 2nd color
✛ 100% Black

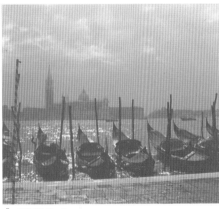

✛ 100% 2nd color
✛ 50% Black

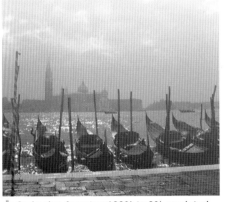

✛ 2nd color: from top 100% to 0% gradated
✛ Black: from top 0% to 100% gradated

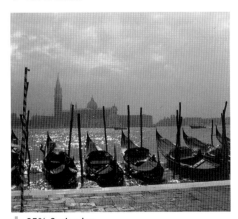

✛ 25% 2nd color
✛ 100% Black

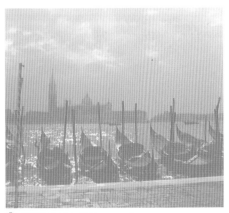

✛ 100% 2nd color
✛ 25% Black

Image for use with color acetate

Green

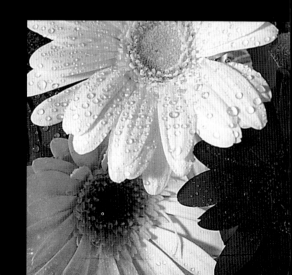

duotones

Sage

Olive

Forest green

✦ **Sage**+**black** duotone

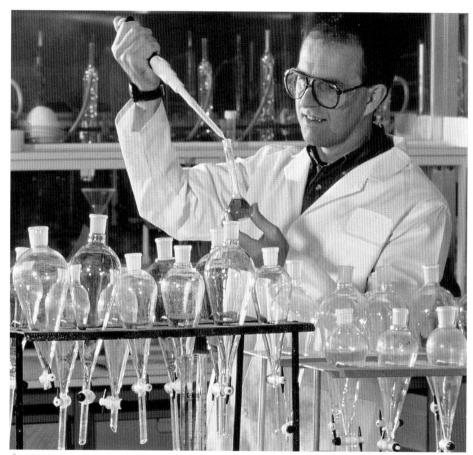

100% 2nd color: standard specification
100% Black: standard specification

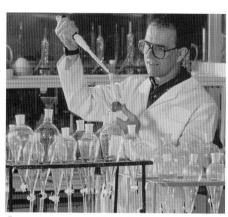

100% 2nd color: flat tint
100% Black: halftone

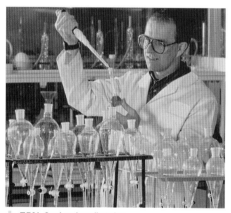

75% 2nd color: flat tint
100% Black: halftone

100% 2nd color: high contrast
100% Black: high contrast

100% 2nd color: low contrast
100% Black: low contrast

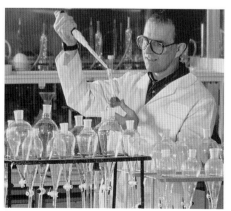

50% 2nd color: flat tint
100% Black: halftone

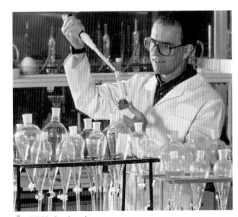

✛ 75% 2nd color
✛ 100% Black

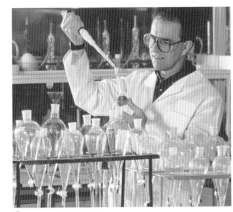

✛ 100% 2nd color
✛ 75% Black

✛ 2nd color: negative halftone
✛ Black: negative halftone

✛ 50% 2nd color
✛ 100% Black

✛ 100% 2nd color
✛ 50% Black

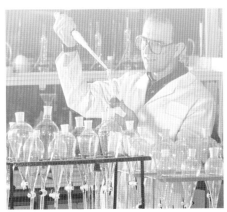

✛ 2nd color: from top 100% to 0% gradated
✛ Black: from top 0% to 100% gradated

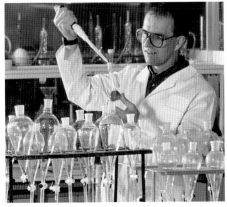

✛ 25% 2nd color
✛ 100% Black

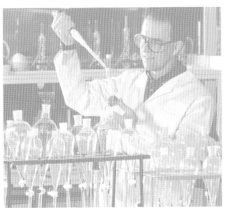

✛ 100% 2nd color
✛ 25% Black

Image for use with color acetate

✦ **Olive**+**black** duotone

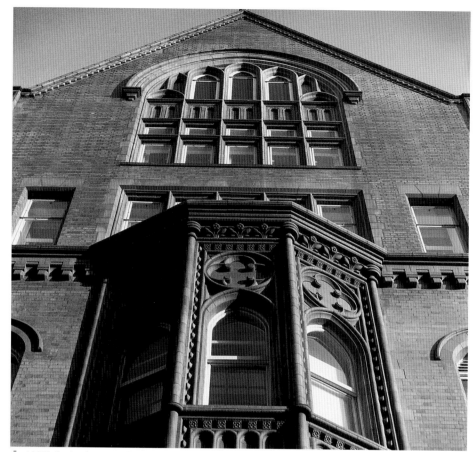

✦ 100% 2nd color: standard specification
✦ 100% Black: standard specification

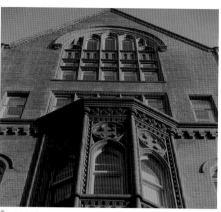

✦ 100% 2nd color: flat tint
✦ 100% Black: halftone

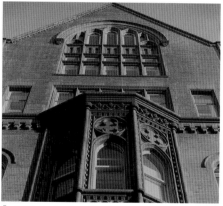

✦ 75% 2nd color: flat tint
✦ 100% Black: halftone

✦ 100% 2nd color: high contrast
✦ 100% Black: high contrast

✦ 100% 2nd color: low contrast
✦ 100% Black: low contrast

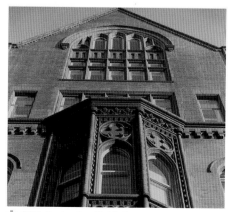

✦ 50% 2nd color: flat tint
✦ 100% Black: halftone

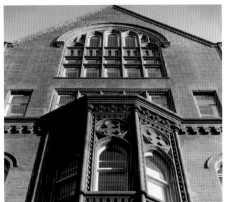

�֍ 75% 2nd color
✤ 100% Black

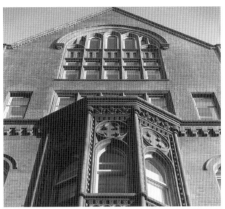

✤ 100% 2nd color
✤ 75% Black

✤ 2nd color: negative halftone
✤ Black: negative halftone

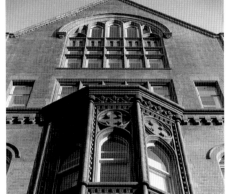

✤ 50% 2nd color
✤ 100% Black

✤ 100% 2nd color
✤ 50% Black

✤ 2nd color: from top 100% to 0% gradated
✤ Black: from top 0% to 100% gradated

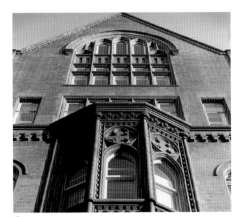

✤ 25% 2nd color
✤ 100% Black

✤ 100% 2nd color
✤ 25% Black

Image for use with color acetate

✚ **Forest green+black** duotone

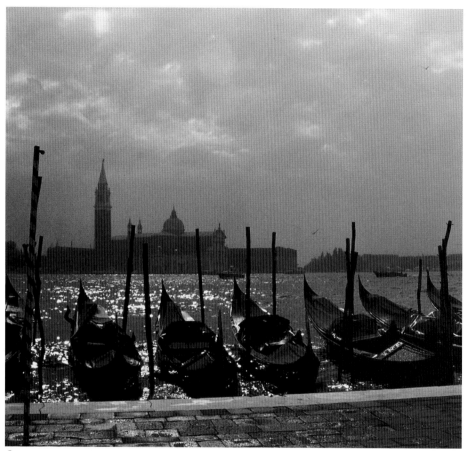

✚ 100% 2nd color: standard specification
✚ 100% Black: standard specification

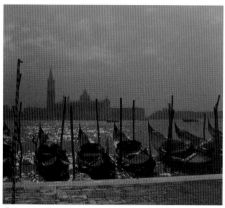

✚ 100% 2nd color: flat tint
✚ 100% Black: halftone

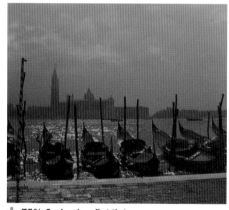

✚ 75% 2nd color: flat tint
✚ 100% Black: halftone

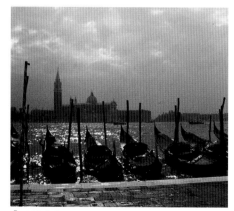

✚ 100% 2nd color: high contrast
✚ 100% Black: high contrast

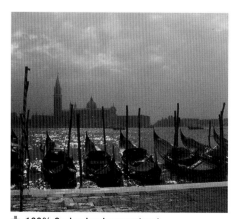

✚ 100% 2nd color: low contrast
✚ 100% Black: low contrast

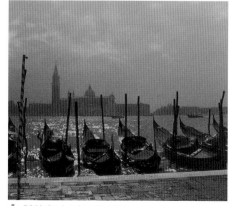

✚ 50% 2nd color: flat tint
✚ 100% Black: halftone

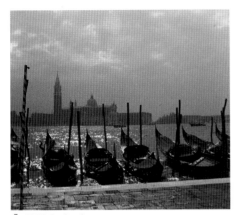

✛ 75% 2nd color
✜ 100% Black

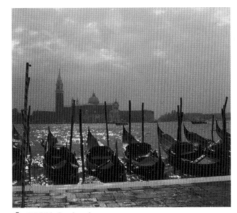

✛ 100% 2nd color
✜ 75% Black

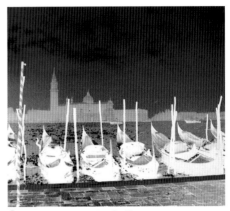

✜ 2nd color: negative halftone
✜ Black: negative halftone

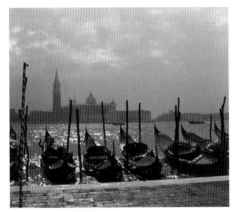

✛ 50% 2nd color
✜ 100% Black

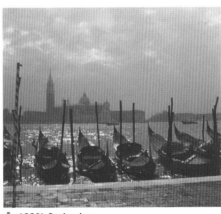

✛ 100% 2nd color
✜ 50% Black

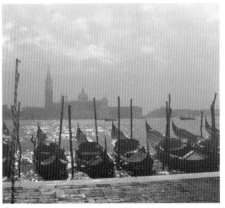

✜ 2nd color: from top 100% to 0% gradated
✜ Black: from top 0% to 100% gradated

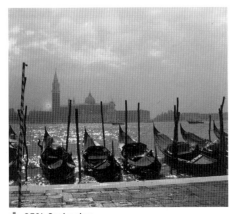

✛ 25% 2nd color
✜ 100% Black

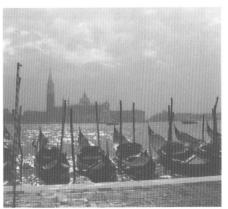

✛ 100% 2nd color
✜ 25% Black

Image for use with color acetate

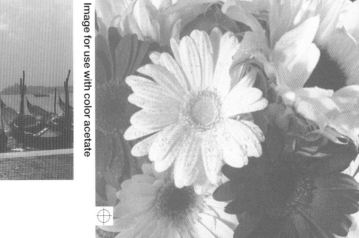

Brown

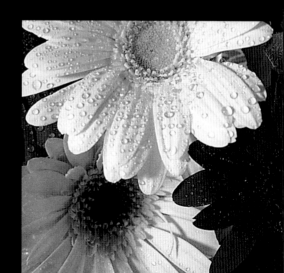

duotones

Burnt umber **Brown** **Terracotta**

✛ **Burnt umber+black** duotone

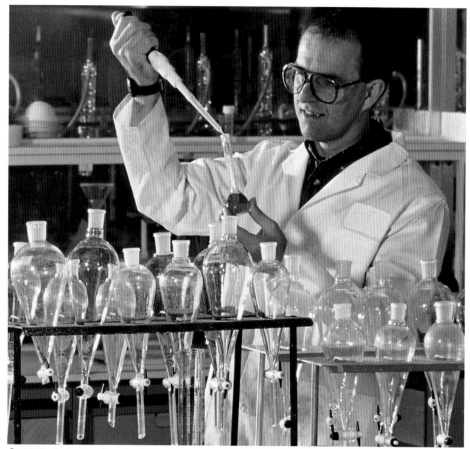

✛ 100% 2nd color: standard specification
✛ 100% Black: standard specification

✛ 100% 2nd color: flat tint
✛ 100% Black: halftone

✛ 75% 2nd color: flat tint
✛ 100% Black: halftone

✛ 100% 2nd color: high contrast
✛ 100% Black: high contrast

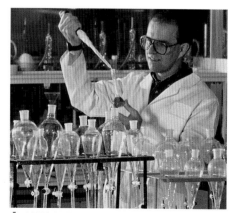

✛ 100% 2nd color: low contrast
✛ 100% Black: low contrast

✛ 50% 2nd color: flat tint
✛ 100% Black: halftone

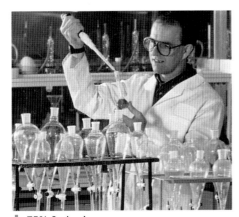

✛ 75% 2nd color
❖ 100% Black

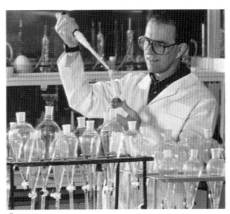

✛ 100% 2nd color
❖ 75% Black

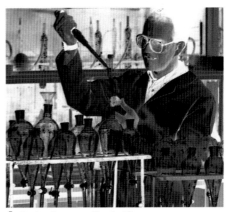

✛ 2nd color: negative halftone
❖ Black: negative halftone

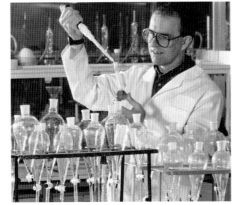

✛ 50% 2nd color
❖ 100% Black

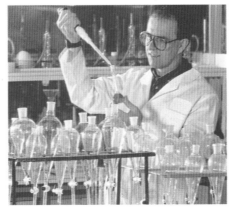

✛ 100% 2nd color
❖ 50% Black

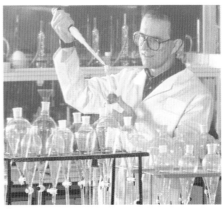

✛ 2nd color: from top 100% to 0% gradated
❖ Black: from top 0% to 100% gradated

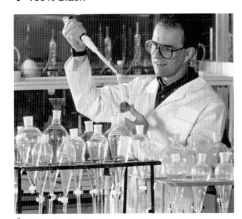

✛ 25% 2nd color
❖ 100% Black

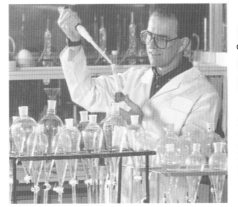

✛ 100% 2nd color
❖ 25% Black

Image for use with color acetate

Brown+**black** duotone

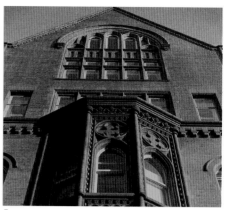

✤ 100% 2nd color: flat tint
✜ 100% Black: halftone

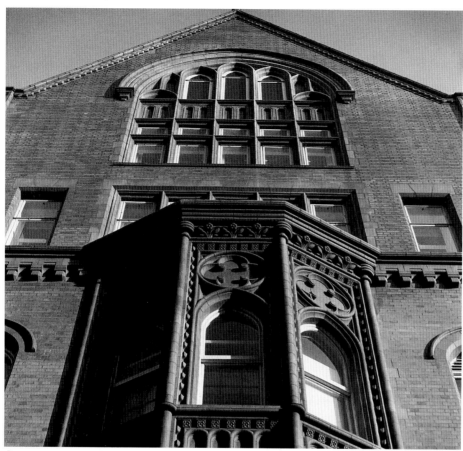

✤ 100% 2nd color: standard specification
✜ 100% Black: standard specification

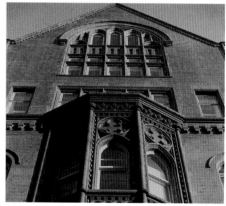

✤ 75% 2nd color: flat tint
✜ 100% Black: halftone

✤ 100% 2nd color: high contrast
✜ 100% Black: high contrast

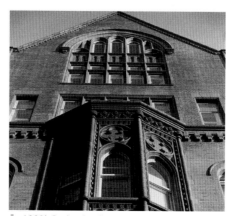

✤ 100% 2nd color: low contrast
✜ 100% Black: low contrast

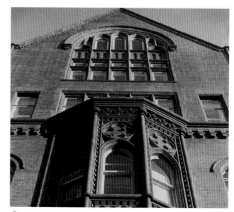

✤ 50% 2nd color: flat tint
✜ 100% Black: halftone

✛ 75% 2nd color
✛ 100% Black

✛ 100% 2nd color
✛ 75% Black

✛ 2nd color: negative halftone
✛ Black: negative halftone

✛ 50% 2nd color
✛ 100% Black

✛ 100% 2nd color
✛ 50% Black

✛ 2nd color: from top 100% to 0% gradated
✛ Black: from top 0% to 100% gradated

✛ 25% 2nd color
✛ 100% Black

✛ 100% 2nd color
✛ 25% Black

Image for use with color acetate

✛ **Terracotta**+**black** duotone

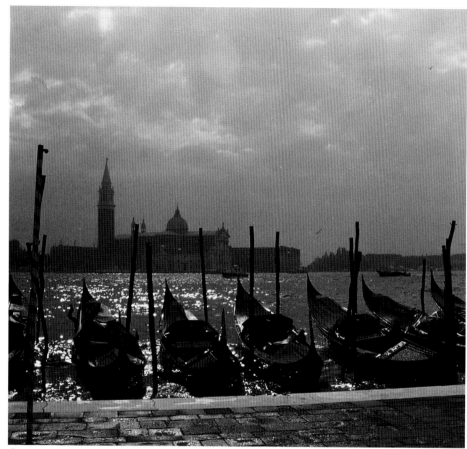

✛ 100% 2nd color: standard specification
✛ 100% Black: standard specification

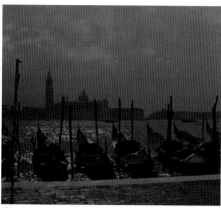

✛ 100% 2nd color: flat tint
✛ 100% Black: halftone

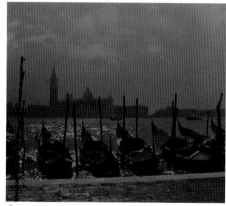

✛ 75% 2nd color: flat tint
✛ 100% Black: halftone

✛ 100% 2nd color: high contrast
✛ 100% Black: high contrast

✛ 100% 2nd color: low contrast
✛ 100% Black: low contrast

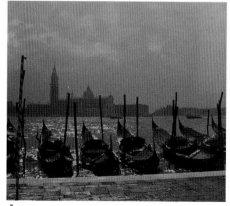

✛ 50% 2nd color: flat tint
✛ 100% Black: halftone

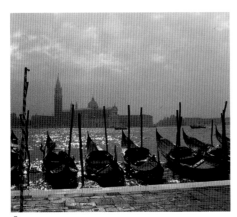

✤ 75% 2nd color
✤ 100% Black

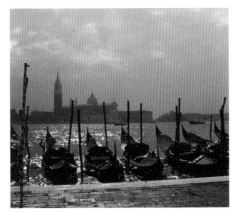

✤ 100% 2nd color
✤ 75% Black

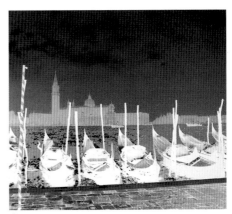

✤ 2nd color: negative halftone
✤ Black: negative halftone

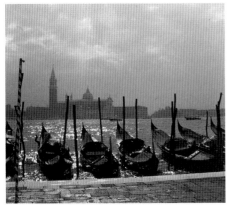

✤ 50% 2nd color
✤ 100% Black

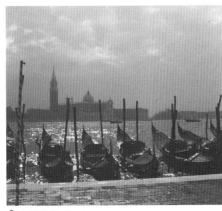

✤ 100% 2nd color
✤ 50% Black

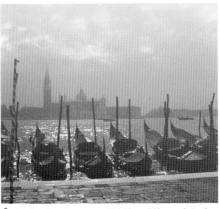

✤ 2nd color: from top 100% to 0% gradated
✤ Black: from top 0% to 100% gradated

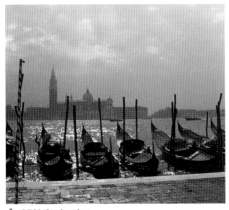

✤ 25% 2nd color
✤ 100% Black

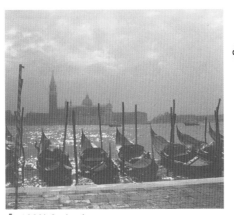

✤ 100% 2nd color
✤ 25% Black

Image for use with color acetate

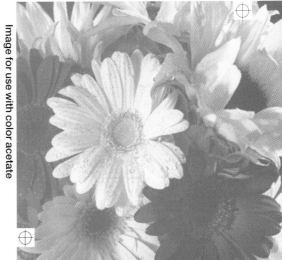

Dark

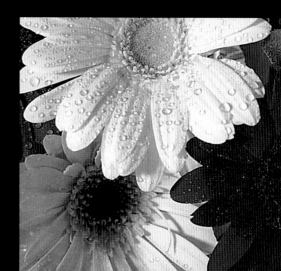

duotones

Dark blue

Hunter green

Raw umber

✤ **Dark blue+black** duotone

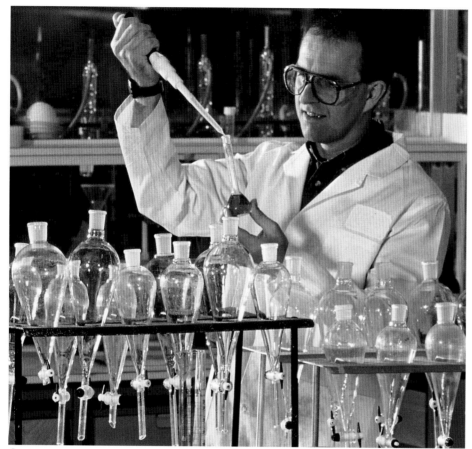

✤ 100% 2nd color: standard specification
✤ 100% Black: standard specification

✤ 100% 2nd color: flat tint
✤ 100% Black: halftone

✤ 75% 2nd color: flat tint
✤ 100% Black: halftone

✤ 100% 2nd color: high contrast
✤ 100% Black: high contrast

✤ 100% 2nd color: low contrast
✤ 100% Black: low contrast

✤ 50% 2nd color: flat tint
✤ 100% Black: halftone

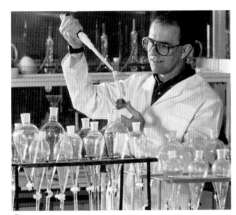

✤ 75% 2nd color
✤ 100% Black

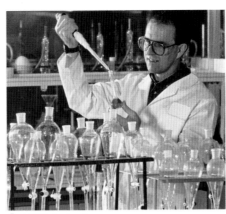

✤ 100% 2nd color
✤ 75% Black

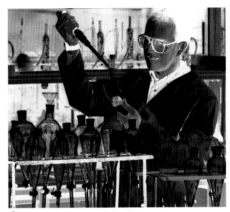

✤ 2nd color: negative halftone
✤ Black: negative halftone

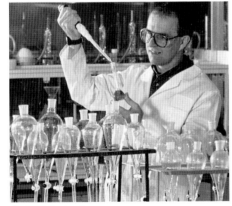

✤ 50% 2nd color
✤ 100% Black

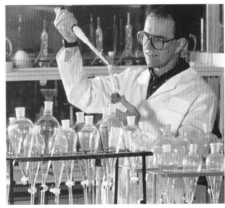

✤ 100% 2nd color
✤ 50% Black

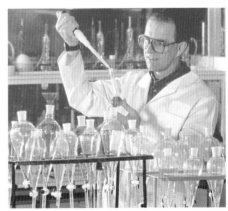

✤ 2nd color: from top 100% to 0% gradated
✤ Black: from top 0% to 100% gradated

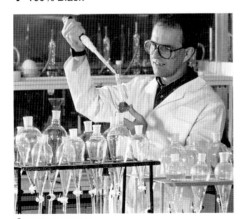

✤ 25% 2nd color
✤ 100% Black

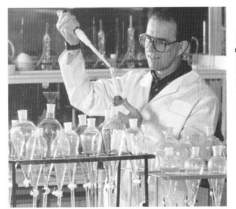

✤ 100% 2nd color
✤ 25% Black

Image for use with color acetate

✢ **Hunter green**+**black** duotone

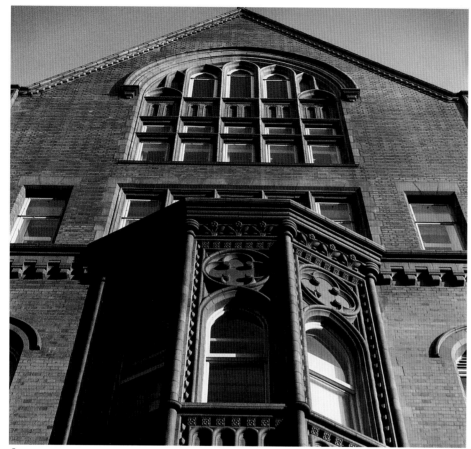

� 100% 2nd color: standard specification
✢ 100% Black: standard specification

✢ 100% 2nd color: flat tint
✢ 100% Black: halftone

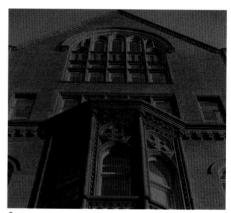

✢ 75% 2nd color: flat tint
✢ 100% Black: halftone

✢ 100% 2nd color: high contrast
✢ 100% Black: high contrast

✢ 100% 2nd color: low contrast
✢ 100% Black: low contrast

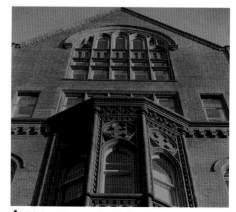

✢ 50% 2nd color: flat tint
✢ 100% Black: halftone

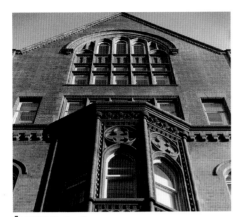

✤ 75% 2nd color
✤ 100% Black

✤ 100% 2nd color
✤ 75% Black

✤ 2nd color: negative halftone
✤ Black: negative halftone

✤ 50% 2nd color
✤ 100% Black

✤ 100% 2nd color
✤ 50% Black

✤ 2nd color: from top 100% to 0% gradated
✤ Black: from top 0% to 100% gradated

✤ 25% 2nd color
✤ 100% Black

✤ 100% 2nd color
✤ 25% Black

Image for use with color acetate

✢ **Raw umber**+**black** duotone

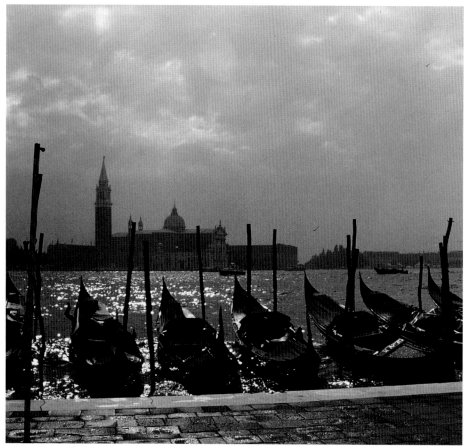

✢ 100% 2nd color: standard specification
✢ 100% Black: standard specification

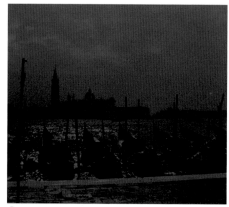

✢ 100% 2nd color: flat tint
✢ 100% Black: halftone

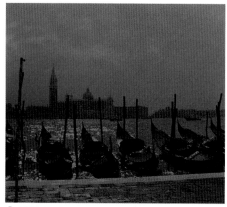

✢ 75% 2nd color: flat tint
✢ 100% Black: halftone

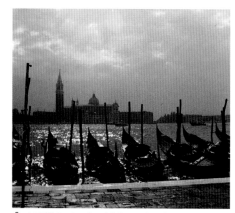

✢ 100% 2nd color: high contrast
✢ 100% Black: high contrast

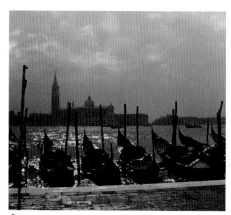

✢ 100% 2nd color: low contrast
✢ 100% Black: low contrast

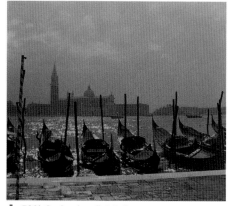

✢ 50% 2nd color: flat tint
✢ 100% Black: halftone

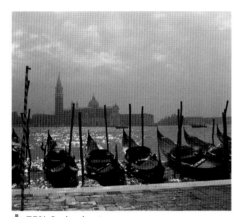

✛ 75% 2nd color
✛ 100% Black

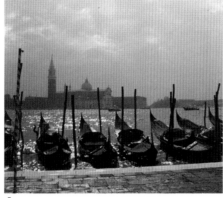

✛ 100% 2nd color
✛ 75% Black

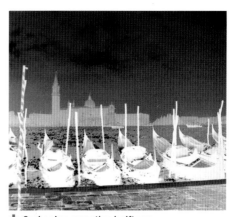

✛ 2nd color: negative halftone
✛ Black: negative halftone

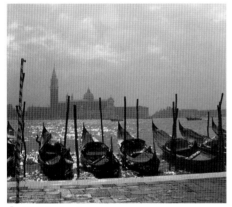

✛ 50% 2nd color
✛ 100% Black

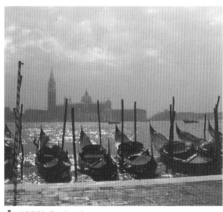

✛ 100% 2nd color
✛ 50% Black

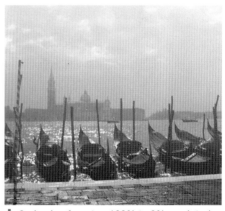

✛ 2nd color: from top 100% to 0% gradated
✛ Black: from top 0% to 100% gradated

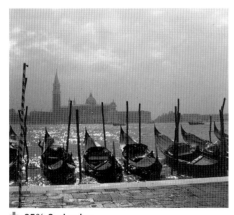

✛ 25% 2nd color
✛ 100% Black

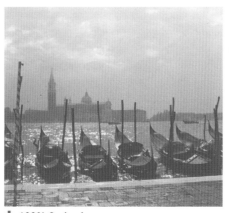

✛ 100% 2nd color
✛ 25% Black

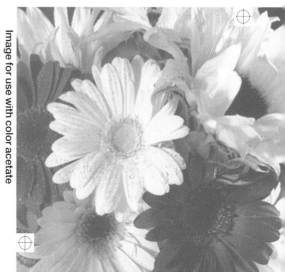

Image for use with color acetate

Gray

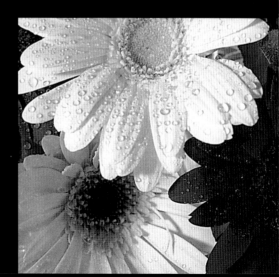

duotones

Light gray

Cool gray

Warm gray

✛ **Light gray**+**black** duotone

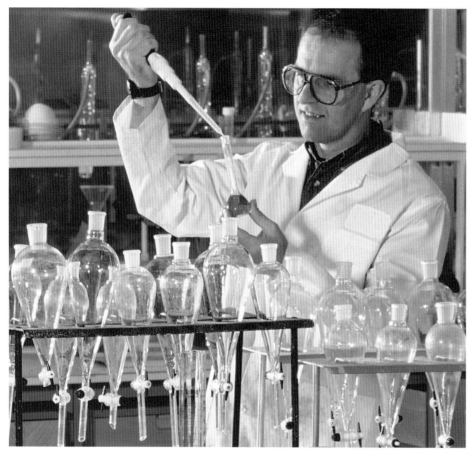

✛ 100% 2nd color: standard specification
✛ 100% Black: standard specification

✛ 100% 2nd color: flat tint
✛ 100% Black: halftone

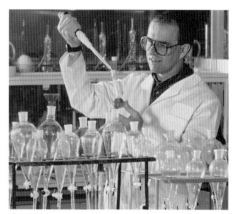

✛ 75% 2nd color: flat tint
✛ 100% Black: halftone

✛ 100% 2nd color: high contrast
✛ 100% Black: high contrast

✛ 100% 2nd color: low contrast
✛ 100% Black: low contrast

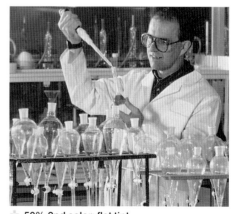

✛ 50% 2nd color: flat tint
✛ 100% Black: halftone

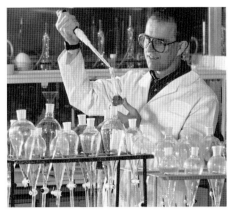

75% 2nd color
100% Black

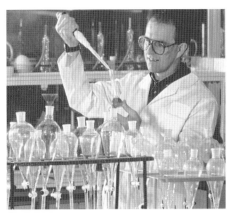

100% 2nd color
75% Black

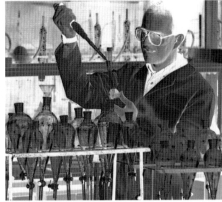

2nd color: negative halftone
Black: negative halftone

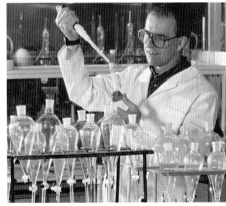

50% 2nd color
100% Black

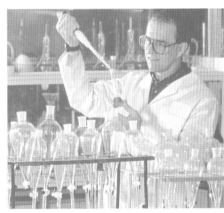

100% 2nd color
50% Black

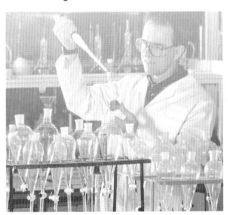

2nd color: from top 100% to 0% gradated
Black: from top 0% to 100% gradated

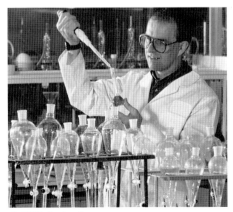

25% 2nd color
100% Black

100% 2nd color
25% Black

Image for use with color acetate

✛ **Cool gray**+**black** duotone

✛ 100% 2nd color: standard specification
✛ 100% Black: standard specification

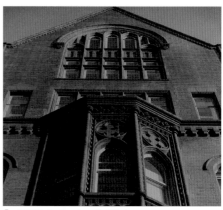

✛ 100% 2nd color: flat tint
✛ 100% Black: halftone

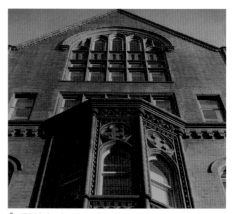

✛ 75% 2nd color: flat tint
✛ 100% Black: halftone

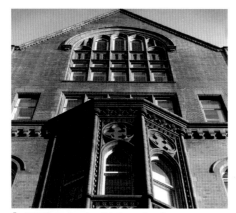

✛ 100% 2nd color: high contrast
✛ 100% Black: high contrast

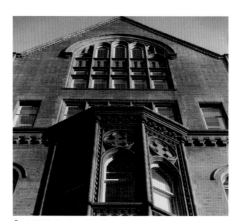

✛ 100% 2nd color: low contrast
✛ 100% Black: low contrast

✛ 50% 2nd color: flat tint
✛ 100% Black: halftone

✛ 75% 2nd color
✛ 100% Black

✛ 100% 2nd color
✛ 75% Black

✛ 2nd color: negative halftone
✛ Black: negative halftone

✛ 50% 2nd color
✛ 100% Black

✛ 100% 2nd color
✛ 50% Black

✛ 2nd color: from top 100% to 0% gradated
✛ Black: from top 0% to 100% gradated

✛ 25% 2nd color
✛ 100% Black

✛ 100% 2nd color
✛ 25% Black

Image for use with color acetate

✦ **Warm gray+black** duotone

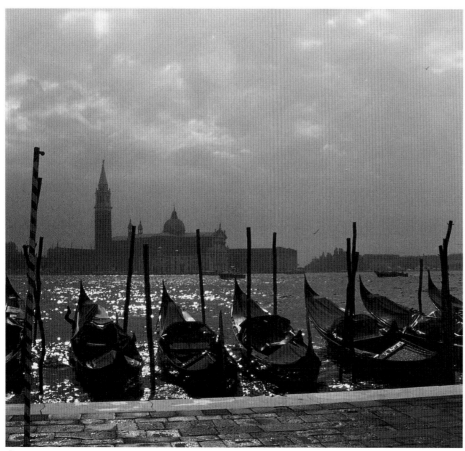

✦ 100% 2nd color: standard specification
✦ 100% Black: standard specification

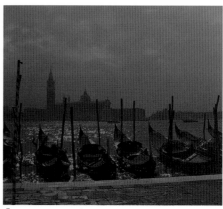

✦ 100% 2nd color: flat tint
✦ 100% Black: halftone

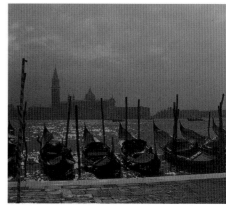

✦ 75% 2nd color: flat tint
✦ 100% Black: halftone

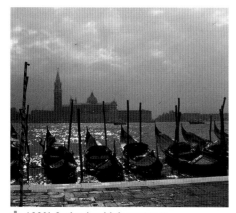

✦ 100% 2nd color: high contrast
✦ 100% Black: high contrast

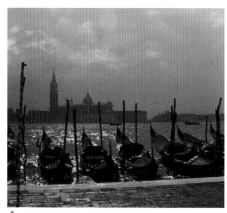

✦ 100% 2nd color: low contrast
✦ 100% Black: low contrast

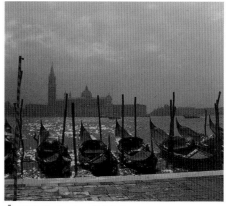

✦ 50% 2nd color: flat tint
✦ 100% Black: halftone

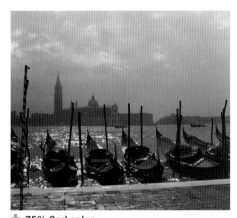

✛ 75% 2nd color
✛ 100% Black

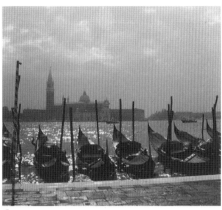

✛ 100% 2nd color
✛ 75% Black

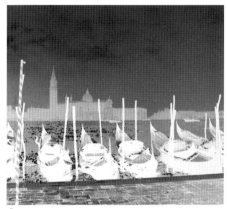

✛ 2nd color: negative halftone
✛ Black: negative halftone

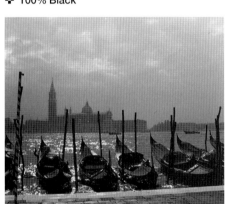

✛ 50% 2nd color
✛ 100% Black

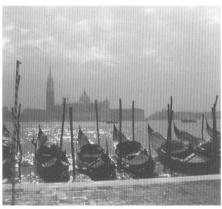

✛ 100% 2nd color
✛ 50% Black

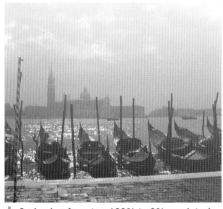

✛ 2nd color: from top 100% to 0% gradated
✛ Black: from top 0% to 100% gradated

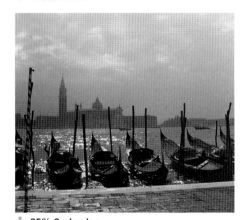

✛ 25% 2nd color
✛ 100% Black

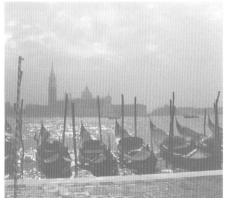

✛ 100% 2nd color
✛ 25% Black

Image for use with color acetate

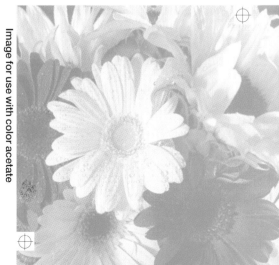

Metallic

duotones

Silver **Bronze** **Gold**

✛ **Silver**+**black** duotone

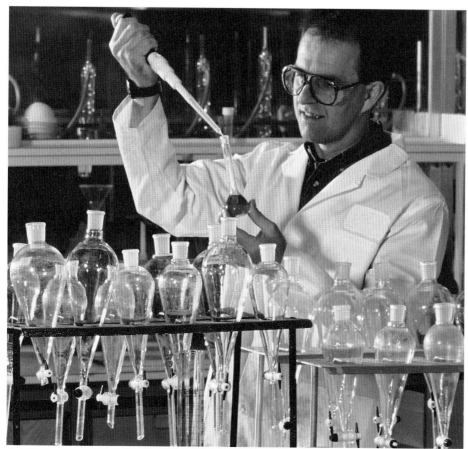

✛ 100% 2nd color: standard specification
✛ 100% Black: standard specification

✛ 100% 2nd color: flat tint
✛ 100% Black: halftone

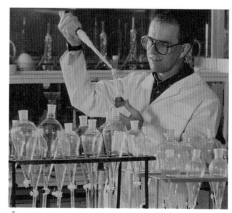

✛ 75% 2nd color: flat tint
✛ 100% Black: halftone

✛ 100% 2nd color: high contrast
✛ 100% Black: high contrast

✛ 100% 2nd color: low contrast
✛ 100% Black: low contrast

✛ 50% 2nd color: flat tint
✛ 100% Black: halftone

✛ 75% 2nd color
✛ 100% Black

✛ 100% 2nd color
✛ 75% Black

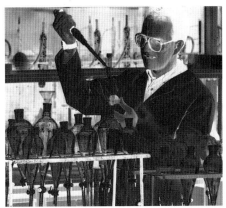

✛ 2nd color: negative halftone
✛ Black: negative halftone

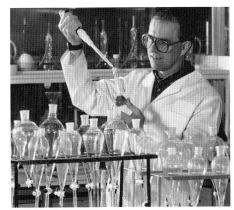

✛ 50% 2nd color
✛ 100% Black

✛ 100% 2nd color
✛ 50% Black

✛ 2nd color: from top 100% to 0% gradated
✛ Black: from top 0% to 100% gradated

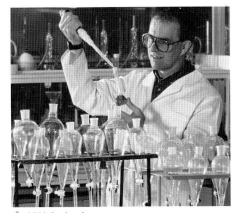

✛ 25% 2nd color
✛ 100% Black

✛ 100% 2nd color
✛ 25% Black

Image for use with color acetate

✤ **Bronze+black** duotone

✤ 100% 2nd color: standard specification
✤ 100% Black: standard specification

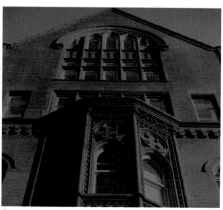

✤ 100% 2nd color: flat tint
✤ 100% Black: halftone

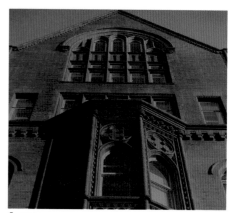

✤ 75% 2nd color: flat tint
✤ 100% Black: halftone

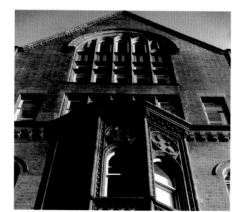

✤ 100% 2nd color: high contrast
✤ 100% Black: high contrast

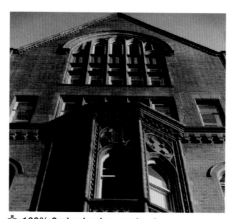

✤ 100% 2nd color: low contrast
✤ 100% Black: low contrast

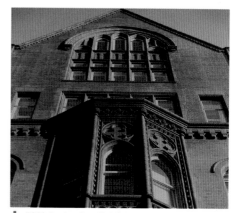

✤ 50% 2nd color: flat tint
✤ 100% Black: halftone

✤ 75% 2nd color
✤ 100% Black

✤ 100% 2nd color
✤ 75% Black

✤ 2nd color: negative halftone
✤ Black: negative halftone

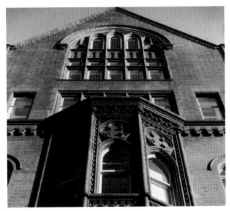

✤ 50% 2nd color
✤ 100% Black

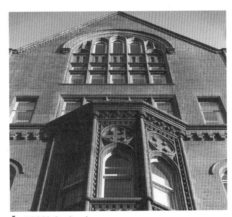

✤ 100% 2nd color
✤ 50% Black

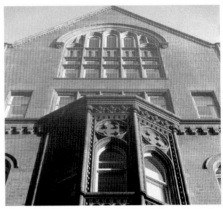

✤ 2nd color: from top 100% to 0% gradated
✤ Black: from top 0% to 100% gradated

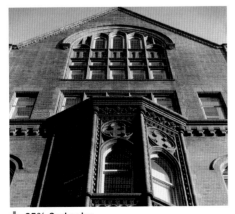

✤ 25% 2nd color
✤ 100% Black

✤ 100% 2nd color
✤ 25% Black

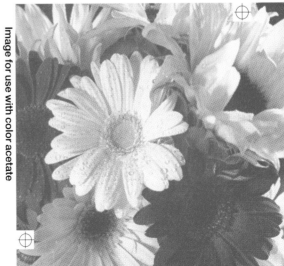

Image for use with color acetate

✛ **Gold+black** duotone

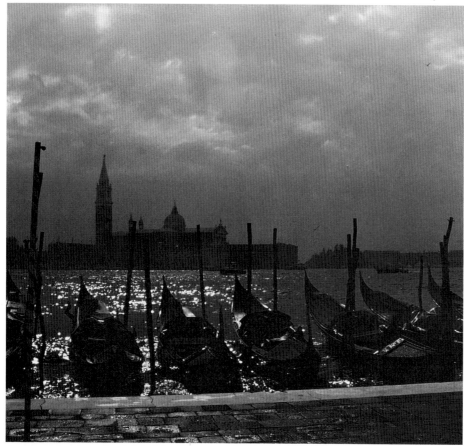

✛ 100% 2nd color: standard specification
✛ 100% Black: standard specification

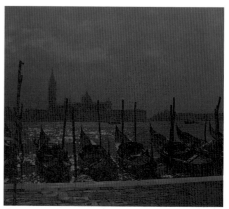

✛ 100% 2nd color: flat tint
✛ 100% Black: halftone

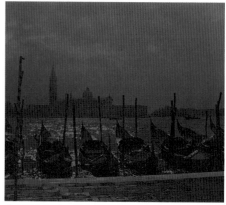

✛ 75% 2nd color: flat tint
✛ 100% Black: halftone

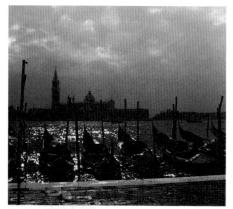

✛ 100% 2nd color: high contrast
✛ 100% Black: high contrast

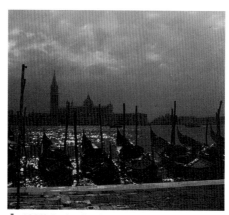

✛ 100% 2nd color: low contrast
✛ 100% Black: low contrast

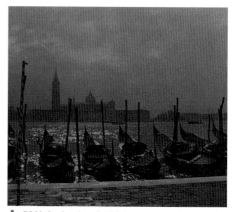

✛ 50% 2nd color: flat tint
✛ 100% Black: halftone

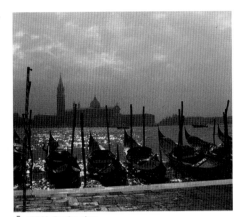

✤ 75% 2nd color
✤ 100% Black

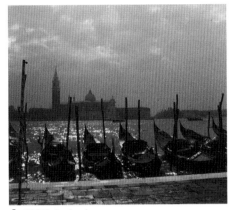

✤ 100% 2nd color
✤ 75% Black

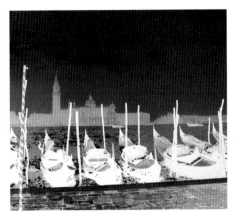

✤ 2nd color: negative halftone
✤ Black: negative halftone

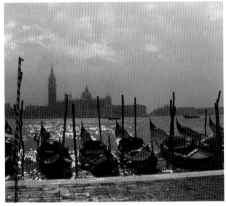

✤ 50% 2nd color
✤ 100% Black

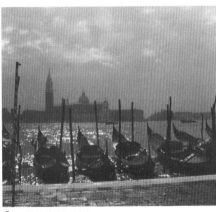

✤ 100% 2nd color
✤ 50% Black

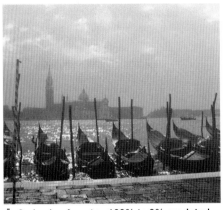

✤ 2nd color: from top 100% to 0% gradated
✤ Black: from top 0% to 100% gradated

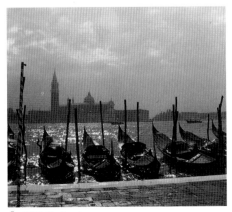

✤ 25% 2nd color
✤ 100% Black

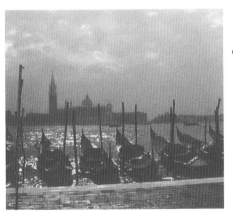

✤ 100% 2nd color
✤ 25% Black

Image for use with color acetate

tritones

&quadtones

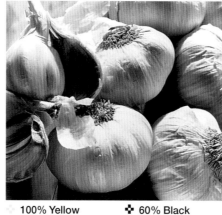

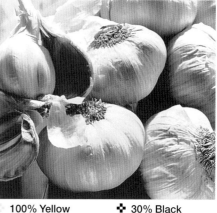

100% Yellow 100% Black
100% Magenta

100% Yellow 60% Black
100% Magenta

100% Yellow 30% Black
100% Magenta

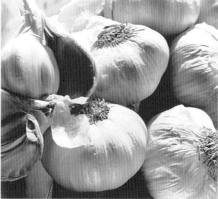
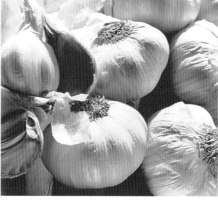

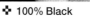

30% Yellow 100% Black
100% Magenta

30% Yellow 60% Black
100% Magenta

30% Yellow 30% Black
100% Magenta

10% Yellow 100% Black
40% Magenta

10% Yellow 60% Black
40% Magenta

10% Yellow 30% Black
40% Magenta

| 40% Yellow | ✤ 10% Cyan |
| 60% Magenta | ✤ 30% Black |

| 40% Yellow | ✤ 10% Cyan |
| 60% Magenta | ✤ 60% Black |

| 40% Yellow | ✤ 10% Cyan |
| 60% Magenta | ✤ 100% Black |

| 5% Yellow | ✤ 30% Black |
| ✤ 20% Magenta | |

| 5% Yellow | ✤ 60% Black |
| ✤ 20% Magenta | |

| 5% Yellow | ✤ 100% Black |
| ✤ 20% Magenta | |

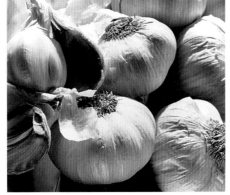

| 40% Yellow | ✤ 40% Cyan |
| ✤ 100% Magenta | ✤ 30% Black |

| 40% Yellow | ✤ 40% Cyan |
| ✤ 100% Magenta | ✤ 60% Black |

| 40% Yellow | ✤ 40% Cyan |
| ✤ 100% Magenta | ✤ 100% Black |

Yellow tritones+quadtones

Using 4 color process printing

100% Yellow 100% Black
30% Magenta

100% Yellow 60% Black
30% Magenta

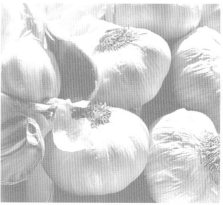

100% Yellow 30% Black
30% Magenta

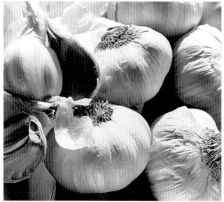

30% Yellow 100% Black
10% Magenta

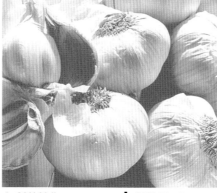

30% Yellow 60% Black
10% Magenta

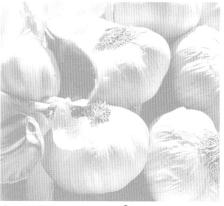

30% Yellow 30% Black
10% Magenta

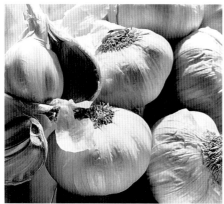

70% Yellow 15% Cyan
20% Magenta 100% Black

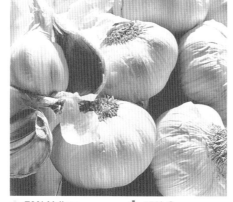

70% Yellow 15% Cyan
20% Magenta 60% Black

70% Yellow 15% Cyan
20% Magenta 30% Black

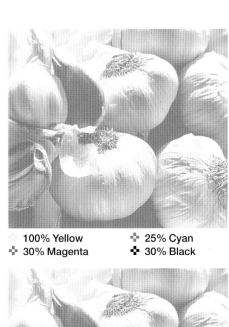

| 100% Yellow | 25% Cyan |
| 30% Magenta | 30% Black |

| 100% Yellow | 25% Cyan |
| 30% Magenta | 60% Black |

| 100% Yellow | 25% Cyan |
| 30% Magenta | 100% Black |

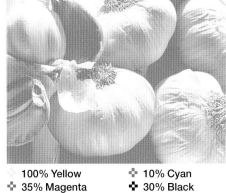
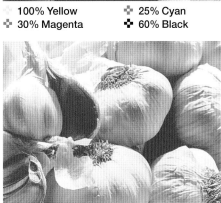

| 100% Yellow | 10% Cyan |
| 35% Magenta | 30% Black |

| 100% Yellow | 10% Cyan |
| 35% Magenta | 60% Black |

| 100% Yellow | 10% Cyan |
| 35% Magenta | 100% Black |

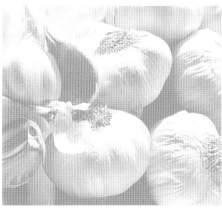

| 50% Yellow | 30% Black |
| 10% Magenta | |

| 50% Yellow | 60% Black |
| 10% Magenta | |

| 50% Yellow | 100% Black |
| 10% Magenta | |

Green tritones+quadtones
Using 4 color process printing

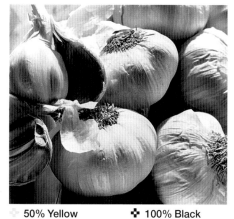

50% Yellow ✚ 100% Black
✚ 70% Cyan

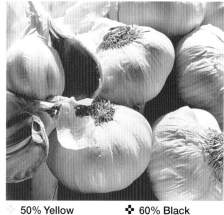

50% Yellow ✚ 60% Black
✚ 70% Cyan

50% Yellow ✚ 30% Black
✚ 70% Cyan

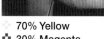

70% Yellow ✚ 70% Cyan
✚ 30% Magenta ✚ 100% Black

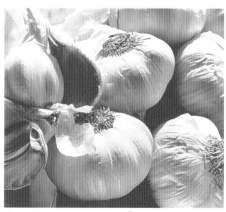

70% Yellow ✚ 70% Cyan
✚ 30% Magenta ✚ 60% Black

70% Yellow ✚ 70% Cyan
✚ 30% Magenta ✚ 30% Black

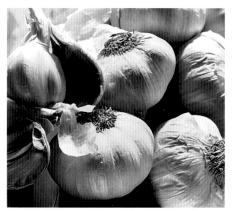

50% Yellow ✚ 100% Black
✚ 100% Cyan

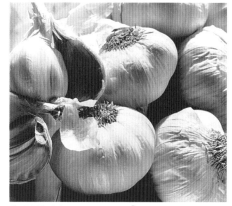

50% Yellow ✚ 60% Black
✚ 100% Cyan

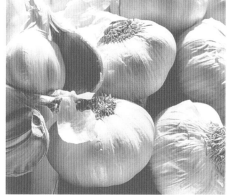

50% Yellow ✚ 30% Black
✚ 100% Cyan

50% Yellow · 100% Cyan
· 30% Magenta · 30% Black

50% Yellow · 100% Cyan
· 30% Magenta · 60% Black

50% Yellow · 100% Cyan
· 30% Magenta · 100% Black

25% Yellow · 30% Black
· 25% Cyan

25% Yellow · 60% Black
· 25% Cyan

25% Yellow · 100% Black
· 25% Cyan

100% Yellow · 30% Black
· 100% Cyan

100% Yellow · 60% Black
· 100% Cyan

100% Yellow · 100% Black
· 100% Cyan

Brown tritones+quadtones

❖❖❖ Using 4 color process printing

❖ 65% Yellow	❖ 30% Cyan
❖ 65% Magenta	❖ 100% Black

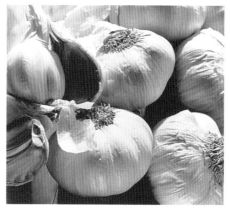

❖ 65% Yellow	❖ 30% Cyan
❖ 65% Magenta	❖ 60% Black

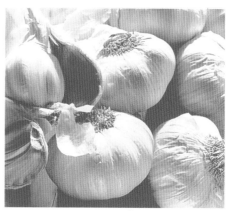

❖ 65% Yellow	❖ 30% Cyan
❖ 65% Magenta	❖ 30% Black

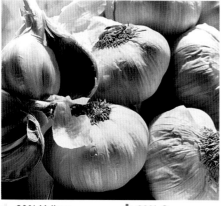

❖ 80% Yellow	❖ 60% Cyan
❖ 80% Magenta	❖ 100% Black

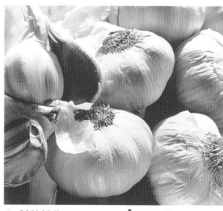

❖ 80% Yellow	❖ 60% Cyan
❖ 80% Magenta	❖ 60% Black

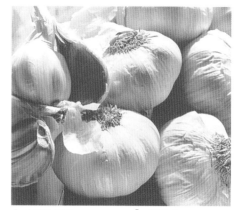

❖ 80% Yellow	❖ 60% Cyan
❖ 80% Magenta	❖ 30% Black

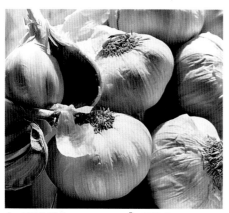

❖ 100% Yellow	❖ 45% Cyan
❖ 65% Magenta	❖ 100% Black

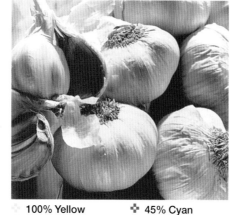

❖ 100% Yellow	❖ 45% Cyan
❖ 65% Magenta	❖ 60% Black

❖ 100% Yellow	❖ 45% Cyan
❖ 65% Magenta	❖ 30% Black

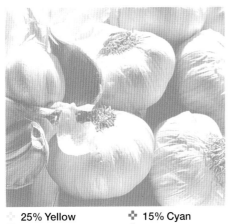

25% Yellow	15% Cyan
30% Magenta	30% Black

25% Yellow	15% Cyan
30% Magenta	60% Black

25% Yellow	15% Cyan
30% Magenta	100% Black

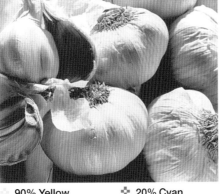

90% Yellow	20% Cyan
60% Magenta	30% Black

90% Yellow	20% Cyan
60% Magenta	60% Black

90% Yellow	20% Cyan
60% Magenta	100% Black

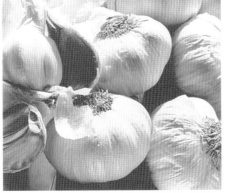

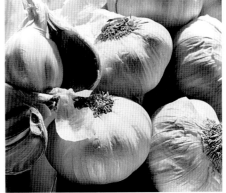

15% Yellow	5% Cyan
15% Magenta	30% Black

15% Yellow	5% Cyan
15% Magenta	60% Black

15% Yellow	5% Cyan
15% Magenta	100% Black

Blue tritones+quadtones

❖❖❖ Using 4 color process printing

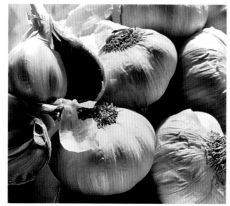

30% Yellow	❖ 85% Cyan
❖ 60% Magenta	❖ 100% Black

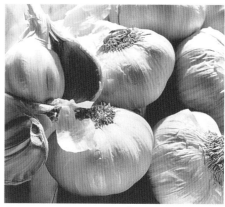

30% Yellow	❖ 85% Cyan
❖ 60% Magenta	❖ 60% Black

30% Yellow	❖ 85% Cyan
❖ 60% Magenta	❖ 30% Black

20% Yellow	❖ 100% Black
❖ 40% Cyan	

20% Yellow	❖ 60% Black
❖ 40% Cyan	

20% Yellow	❖ 30% Black
❖ 40% Cyan	

25% Yellow	❖ 100% Black
❖ 100% Cyan	

25% Yellow	❖ 60% Black
❖ 100% Cyan	

25% Yellow	❖ 30% Black
❖ 100% Cyan	

✤ 70% Magenta ✤ 30% Black
✤ 100% Cyan

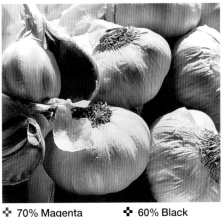

✤ 70% Magenta ✤ 60% Black
✤ 100% Cyan

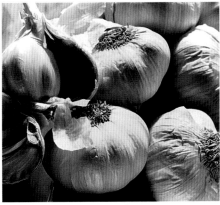

✤ 70% Magenta ✤ 100% Black
✤ 100% Cyan

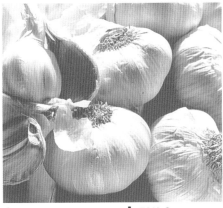

✤ 20% Yellow ✤ 70% Cyan
✤ 20% Magenta ✤ 30% Black

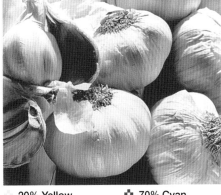

✤ 20% Yellow ✤ 70% Cyan
✤ 20% Magenta ✤ 60% Black

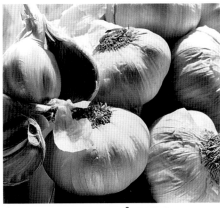

✤ 20% Yellow ✤ 70% Cyan
✤ 20% Magenta ✤ 100% Black

✤ 25% Yellow ✤ 75% Cyan
✤ 45% Magenta ✤ 30% Black

✤ 25% Yellow ✤ 75% Cyan
✤ 45% Magenta ✤ 60% Black

✤ 25% Yellow ✤ 75% Cyan
✤ 45% Magenta ✤ 100% Black

Light tritones+quadtones
Using 4 color process printing

- 5% Yellow
- 5% Magenta
- ✤ 5% Cyan
- ✤ 100% Black

- 5% Yellow
- 5% Magenta
- ✤ 5% Cyan
- ✤ 60% Black

- 5% Yellow
- 5% Magenta
- ✤ 5% Cyan
- ✤ 30% Black

- 15% Yellow
- 15% Magenta
- ✤ 5% Cyan
- ✤ 100% Black

- 15% Yellow
- 15% Magenta
- ✤ 5% Cyan
- ✤ 60% Black

- 15% Yellow
- 15% Magenta
- ✤ 5% Cyan
- ✤ 30% Black

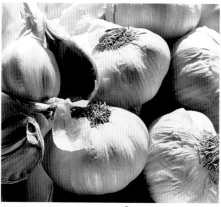

- 20% Yellow
- 20% Magenta
- ✤ 20% Cyan
- ✤ 100% Black

- 20% Yellow
- 20% Magenta
- ✤ 20% Cyan
- ✤ 60% Black

- 20% Yellow
- 20% Magenta
- ✤ 20% Cyan
- ✤ 30% Black

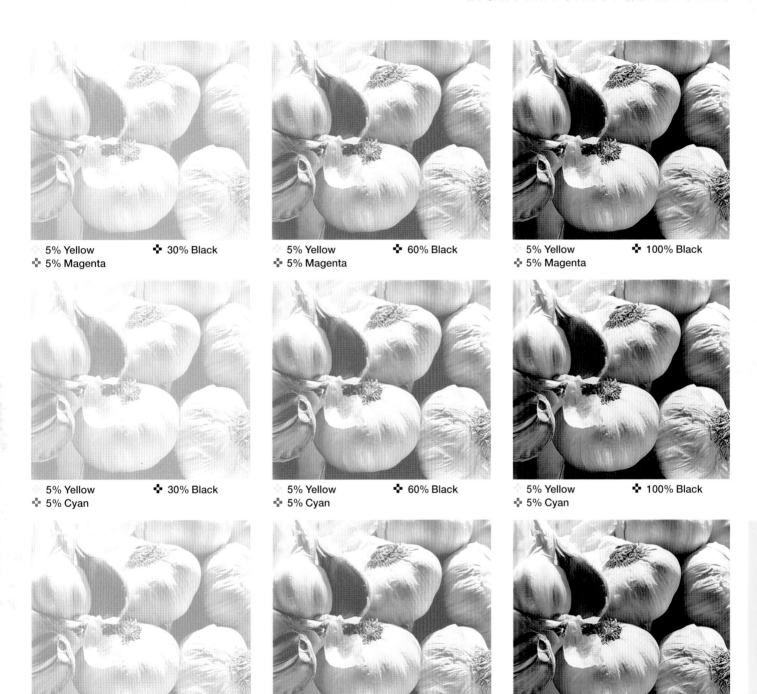

5% Yellow ✛ 30% Black
✛ 5% Magenta

5% Yellow ✛ 60% Black
✛ 5% Magenta

5% Yellow ✛ 100% Black
✛ 5% Magenta

5% Yellow ✛ 30% Black
✛ 5% Cyan

5% Yellow ✛ 60% Black
✛ 5% Cyan

5% Yellow ✛ 100% Black
✛ 5% Cyan

25% Yellow ✛ 10% Cyan
✛ 10% Magenta ✛ 30% Black

25% Yellow ✛ 10% Cyan
✛ 10% Magenta ✛ 60% Black

25% Yellow ✛ 10% Cyan
✛ 10% Magenta ✛ 100% Black

Dark tritones+quadtones
❖❖❖ Using 4 color process printing

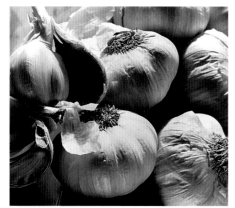

100% Yellow	❖ 100% Cyan
❖ 75% Magenta	❖ 100% Black

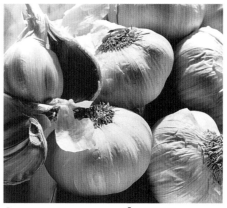

100% Yellow	❖ 100% Cyan
❖ 75% Magenta	❖ 60% Black

100% Yellow	❖ 100% Cyan
❖ 75% Magenta	❖ 30% Black

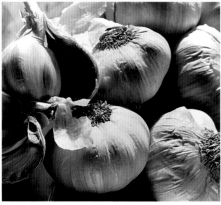

80% Yellow	❖ 80% Cyan
❖ 80% Magenta	❖ 100% Black

80% Yellow	❖ 80% Cyan
❖ 80% Magenta	❖ 60% Black

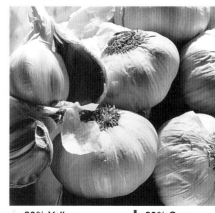

80% Yellow	❖ 80% Cyan
❖ 80% Magenta	❖ 30% Black

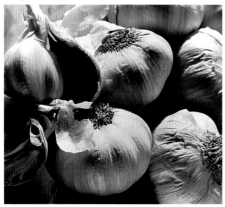

100% Yellow	❖ 60% Cyan
❖ 100% Magenta	❖ 100% Black

100% Yellow	❖ 60% Cyan
❖ 100% Magenta	❖ 60% Black

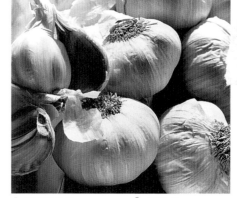

100% Yellow	❖ 60% Cyan
❖ 100% Magenta	❖ 30% Black

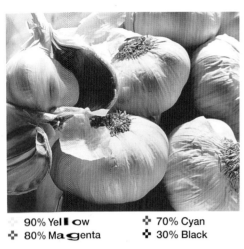

90% Ye**ll**ow ✛ 70% Cyan
✛ 80% Ma**g**enta ✛ 30% Black

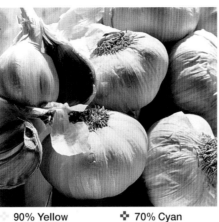

90% Yellow ✛ 70% Cyan
✛ 80% Magenta ✛ 60% Black

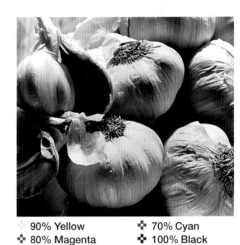

90% Yellow ✛ 70% Cyan
✛ 80% Magenta ✛ 100% Black

✛ 100% **M**agenta 60% Yellow
✛ 100% **Cy**an ✛ 30% Black

✛ 100% Magenta 60% Yellow
✛ 100% Cyan ✛ 60% Black

✛ 100% Magenta 60% Yellow
✛ 100% Cyan ✛ 100% Black

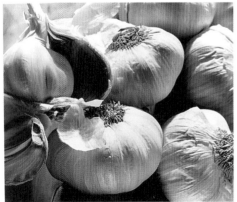

55% Ye**ll**ow ✛ 80% Cyan
✛ 100% **M**agenta ✛ 30% Black

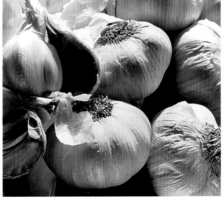

55% Yellow ✛ 80% Cyan
✛ 100% Magenta ✛ 60% Black

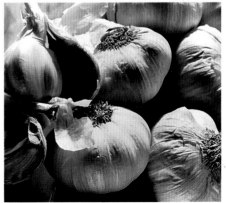

55% Yellow ✛ 80% Cyan
✛ 100% Magenta ✛ 100% Black

Acknowledgements

Quarto would like to acknowledge and thank the following for permission to use copyright material.

page 6 Ashmolean Museum, Oxford; *page 8* packaging designed for Harvey Nichols by Michael Nash Associates, London; *page 9 above* brochure for Leo's Dancewear designed by Nicholas Associates, Chicago; *page 9 below left* 1991 Observer Calendar designed by CDT Design Ltd, London; *page 9 below right* brochure designed for Catalyst Consulting Team by Gee and Chung Design, San Francisco, photographer Geoffrey Nelson; *page 10 clockwise, from above:* two images from *Espresso: Culture and Cuisine*, by Karl Petzke and Sara Slavin, published by Chronicle Books; pages from *Legends of the Silent Screen* designed by the Supon Design Group, Washington DC; figure references from *The Illustrator's Reference Manual: Figures*, by Bloomsbury Publishing Ltd; *page 11* programme designed for the Crafts Council by John Rushworth, Pentagram Design Ltd, London. ·

Repeating photograph of a scientist is by Andrew Brookes. All other photographs by Phil Starling and Quarto Publishing.

Thanks to Adobe Systems Incorporated for use of text and examples from Adobe Photoshop reference manual and to Andrew Clark for his help with this project.